Conversations
with my Gardener

Conversations
with my Gardener

HENRI CUECO

Translated from the French
by GEORGE MILLER

Granta Books
London

Granta Publications, 2/3 Hanover Yard, Noel Road, London N1 8BE

First published in Great Britain by Granta Books 2005
First published in France as *Dialogue avec mon jardinier*, 2000

ïi institut français

The book is supported by the French Ministry for Foreign Affairs, as part
of the Burgess programme headed for the French Embassy in London
by the Institut Français du Royaume-Uni

A CIP catalogue record for this book
is available from the British Library.

1 3 5 7 9 10 8 6 4 2

ISBN 1 86207 739 8

Typeset by M Rules

Printed and bound in Great Britain by
William Clowes Ltd, Beccles, Suffolk

for Annie

'Are you drawing those nutshells?'

'I'm just drawing what's in front of me.'

'I can get you a whole bagful of shells, if you like. The rats have eaten all the nuts in the attic, and left a pile of them as high as your table. If you want them, there's no shortage.'

He laughs.

*

'What is it you're doing? Drawing the grass? . . . It's good. Really good. No, I'm serious . . . Is it that bit in front of you there that you're doing? It isn't much to look at, is it? Just a bit of grass. That'd never have occurred to me . . .'

'. . .'

'It's boiling hot today. I need to water the lettuces. They're getting as dry as crumpled-up old newspaper. Why are you just doing the grass and not the rest? The trees and sky, and the hill?'

'. . .'

'It's nice here.'

He looks up at the roof, and my gaze follows his.

'I could sit here for ever, quietly drawing like this.'

'For ever might be a bit much, but you've certainly got a nice spot . . . Good high ceiling.'

<p style="text-align:center">*</p>

'Now you're drawing pencil shavings, shells, spent matches, ashes . . .' *He adjusts his glasses.* 'And even the stuff that fell off the roof last night. The wind's brought all sorts of rubbish down . . .'

A long silence.

'It's a bit of a muddle.'

'Not in my drawing. A muddle's when things are out of place, but here everything has its proper place.'

'Anyway, that's not what I came for. I'm just after some string to tie up the lettuces . . . Do you draw string too?'

<p style="text-align:center">*</p>

'Still drawing the dust?'

'. . .'

'Mmm . . . Is it supposed to look nice to go on the wall? To sell? Nothing goes to waste with you, does it? You sharpen your pencils and then draw the shavings. Hah . . .'

'You put plenty of manure on the garden . . . Tell me this – how would you describe a beautiful lettuce?'

'*You* know . . . It's when it's got a firm heart, and it's white and succulent in the middle. Good to eat.'

'Well, it's the same with my drawings.'

'Well, you keep drawing your bits and bobs . . . It doesn't do any harm, I'll grant you that. It's like in photographs – you wouldn't think it was anything to look at it, but you end up noticing things you hadn't spotted before.'

'. . .'

'It takes patience. And time. When you're working, you get caught up in it, and you don't see anything else. But I don't often have the time to spend looking.'

'Don't you ever look at the sunset? Or the stars, or the mist?'

'There's not much to see in the mist.'

'A ray of sunshine in winter, your scooter when it's just been repainted, a woman's skin. You must look at other things apart from your lettuces!'

'Maybe, but I don't really notice them. A woman's skin's different . . . Some things you see without realizing that you're looking at them . . .' *A pause.* 'Your bits and bobs . . .'

'Do you like them?'

'I'm not saying I don't. They're nice. They're good. They look better than in real life.'

'I'll give you one of my drawings if you like.'

'Thank you, but I wouldn't want to deprive you of it . . . I don't know if the wife would understand. She hasn't seen you doing them . . . You should give it to someone who'd get something out of it. It wouldn't look right at home.'

*

'I brought you some leeks from my garden. They'd only have dried out if I'd left them. They're getting tough as old rope . . . You've got your work cut out there. I've left you a whole bundle . . . What are you doing with all those bits of paper?'

'They're for a book.'

'A book?

'A sort of notebook where I draw my "bits and bobs", as you call them, and write down conversations from the day before. Look, on the page I'm drawing today I've written down the conversation we had yesterday lunchtime.'

He puts on his glasses and reads.

'Did I say that?'

'Yes. Yesterday you said: "They're nice. They're good. They look better than in real life."'

'Well, it's true. They *are* good, and better than in real life.'

'And tomorrow I'll write down in my book that after you read it you said that it's true that they're good, and so on.'

'The things that you write down are like the things you draw – they're words that should just be thrown away, things that aren't worth the bother.'

'The remains of our words . . .'

*

'You know du Pont the baker? He's dropped dead just like that. I spoke to him only yesterday. We had a laugh. He didn't look ill – a bit pale maybe, but then he had flour on his face. This morning they found him with his nose in it. He wasn't old, ten years younger than me . . . You know who I mean? He wasn't very tall, a bit stooped, not all that thin. He was always saying: "Fine, fine." He said everything twice. It was a nervous habit. "Nice weather. Nice weather." He wasn't a drinker, he just

5

drank a bit of water because of the flour. "It turns to glue, to glue. That's what sticks to me. Sticks to me," he'd say. His glue's certainly stuck to him now ... Are you drawing stones?'

'Chippings.'

'If you're planning to draw all of them, you're going to be busy. No two of them are the same ...' *He holds out an enormous lettuce.* 'You're not the only one who makes beautiful things – look! It's from my garden. I've been watering them every evening. You'll need to wash the dust off it.'

*

'That's a job of work you've got. You have to know what you're doing ... Well, each to his own. I'm better with my pick ... You need a woman's fingers to do that, not sausage-fingers like mine. I've got the handles of my tools instead of a pencil. But I bet I could mow a field with my scythe quicker than you could draw it ... The colours are nice. I haven't seen you do that before ... You need taste for that. And patience. I could never ...' *He looks at his hands and then looks at mine.* 'Time for my soup. The wife'll be waiting.'

*

'Maybe I'm putting you off, standing here watching you?'

'No, you're not putting me off.'

'I'm casting a shadow.'

'No, you aren't.'

'It's good, but I can't make out what it is . . .'

'. . .'

'Is it finished?'

'No, there's still a lot to do.'

'It takes patience . . . I came to say goodbye. I'm off. I'll come and see you next week. I've got to go and pack. The wife wants us to go to Royan with the firemen on Sunday.'

'Is that the annual outing?'

'Yes, it's the fire brigade's annual trip, the same thing every year. We go in the morning and come back in the evening. We spend most of the day on the bus, but we have a picnic on the beach.'

'Do you look at the view from the bus?'

'Oh, everywhere's the same. Houses, trees, cows in the fields. I nod off. Some of them on the bus sing. Last year a few of them even lost their voices.'

'What do you sing?'

'It's the young folk who sing. I don't know. Whatever young folk sing nowadays. Modern songs. Lively stuff. We leave at four o'clock on Sunday morning and take a snack with us. We stop and have something to eat, and get to the sea about lunchtime. We unpack our stuff, spread out our towels, have our sandwiches and a coffee. Then a paddle in the water. The young ones go right in. They're tough nuts. You should see the waves! They'd knock you off your feet . . . We have a couple of hours at the beach and then come home. That's all, really. There's more singing on the way back. When it gets late, it gets quieter as people drop off. And halfway back we stop for a pee.'

'Do you like the sea?'

'I can take it or leave it.'

'You don't sound too keen . . .'

'I'm not much fussed.'

'Why do you go?'

'Once a year doesn't do any harm. I suppose the sea *is* beautiful. When we arrive, it looks huge. They say it's good for children. The little one used to have swollen glands – Lisou, our youngest, I mean. Well, she only had to look at the sea and they disappeared. And the wife

says it does *her* good, too. She talks about it the rest of the year, wouldn't miss it for the world. Women like the sea. It's good for them. They say it stops them getting goitre . . . But listen to me rabbiting on and the wife waiting . . . Do you like cauliflower?'

'Yes, if they don't smell of fish. Which they do if you put fertilizer on them.'

'I'll bring you one from the garden on Monday. Mine don't smell of fish . . .' *He laughs.* 'What I put down . . .' *He laughs again.* 'For fertilizer . . . isn't fish . . . I'll get you some caulis. They're not as nice to look at as some, but they're not mucked around with.'

'You do it carefully at the bottom of each one?'

'Artisan's manure. Done to order!'

He goes out. I can hear the sound of his scooter.

<p style="text-align:center">∗</p>

'Was Royan good?'

'Much the same as usual.'

'Was the weather nice?'

'No, it rained. We only got off the bus for a drink. You couldn't see much. The clouds came right down to the sea. There wasn't a soul about. The young ones went off

<p style="text-align:center">9</p>

for a while, but they ended up getting stuck in the wet sand. We went to a café by the beach. Me and the wife had a coffee and Lisou had a grenadine. They weren't nice in the café, though. We were the only ones there, but you'd have thought we were putting them out by being there. Unfortunately, Lisou broke a glass. Kids are always doing something, and she knocked the glass with her elbow. I saw it go and tried to catch it, but I was too late. What a song and dance they made! I offered to pay for it. I don't remember what the chap said exactly, but he wanted to sound off at me rather than let me pay. It spoiled the whole trip. I don't like drawing attention to myself. Neither does the wife. We were embarrassed. It's not about the cost of the glass. And Lisou cried. Made herself sick in the end. She spent the whole journey back sitting on her mother's knee.'

'What about the ocean? Tell me about that.'

'You couldn't see more than 300 yards. The rain was bucketing down. It cleared up quickly, mind . . . The rain freshens things up . . . As we were getting back on the coach it looked like it might be brightening up. We thought maybe the sun was going to break through.

Some chance! All that broke through was more rain. But we crossed the road in front of the café and had a bit of a look. You could smell the ocean. You couldn't see anything, but you could tell that it was there. It makes you feel peckish . . . the way it smells. Of the sea, fish, wet sand, salt. That's it. I also remember you could hear birds overhead. You couldn't see far. Gulls, seagulls they were.'

'You saw gulls?'

'Yes, those birds that look like they've got broken wings. And just for a minute, not for long, I forgot about the coach and the broken glass. It's true enough that the sea makes you feel calm. I don't know why. But then the rain came on heavier. We put on our raincoats and huddled in a shelter. Everyone else had gone for a bite to eat on the bus. The sea makes you hungry. I went with Lisou, still whingeing about her drink, and the wife, who was wanting a smoke. We walked for a bit in the rain, then we took shelter, and eventually we got back on the bus. We were all present and correct, so we could go . . . On the whole, it was as good as previous years.'

'And what about Lisou?'

'She had nightmares. She was talking in her sleep.

11

I heard her mother tell her that it was only grenadine she'd spilt, not blood, and that there was no need to make such a palaver.'

*

'I've cut back the brambles down in the meadow for you.'

'I'll take a look.'

'You can see it from here without having to budge. It's the "bottom meadow", as you call it. It's all cleaned up. Looks nice now. A good job well done. I had a bit of trouble getting the roots out. They're tough buggers. Even if you do it thoroughly, there are just as many the next year. You need some weedkiller. If you get the chance, get some selective weedkiller and some mole poison.'

'Write it down for me on a bit of paper.'

'No, you do it. I haven't got my glasses and your writing's better than mine. My handwriting's like a doctor's and I make mistakes . . . Lisou, our youngest, is a cheeky one. She teases me about it . . . But here I am, rambling on again. I'm disturbing you most likely . . .'

'. . .'

'Your drawing's taking shape. It's the field . . . I can see you're looking over there, but I can't see what you see . . .

12

I've tried looking at the grass, but I don't see anything in particular. Maybe that's what you like, the fact that it's ordinary . . . I'll need to cut down the ferns for you. They make a field look a right mess. Hey, that bloody mole is back! Even though I cooked him up a nice little dish, he's resistant to the poison, damn him. All those molehills don't look right in a field. But I'll get him for you. Maybe I'll dig down. If I catch him, I'm going to chop him up in slices . . .'

A long silence.

'I can make out the wild sorrel in that red there. It looks good in your drawing. When it's finished and everything's in place, it'll be lovely. It is already. You need patience to do that. I'd sooner die . . . Still, you have to one day . . .'

'Have to what?'

'Die. You've got time, though. You're young.'

'Meaning?'

'You're younger than me. You've got time. Though that's no guarantee, of course. Look at Bardagaud. You knew him, didn't you? Used to come down the hill on his bike, making a "ding-a-ling" noise with his mouth.'

'And?'

'He's not ding-a-linging any more. He's dead.'

'He's the one who used to race down the hill at full pelt, then stick his right arm out when he wanted to turn left?'

'That sounds like him.'

'The one who was interested in astrophysics?'

'Yes, that's him. Well, he's dead. A car ran him over.'

'He must have put out his right arm to turn left.'

'That might well be it. His head always was in the clouds. He was a radical, the genuine article through and through. He was fond of saying: "Science will bring happiness to mankind." He read everything. One book after another. His house was crammed full of them right up to the ceiling. Apparently he used to have this correspondence with a scholar.'

'Professor Langevin.'

'Something like that. He was a good bloke. Just a working man, but clever. He did nights at the cardboard factory. He used to read his books while he was keeping an eye on the machines. Never nodded off, though.'

'What did he read?'

'You name it. Books of figures. Science books, everything. He knew more than the boss and the engineers.

One day in the factory they got a load of reject books. I say they were rejects, but they looked brand new. Well, the workers pinched as many as they could. They found their way all over town. On our estate there were books with colour pictures of birds, of exotic countries, elephants. Free books. The kind of thing you'd never be able to afford. Well, Bardagaud filled his panniers with them. They were so heavy that he couldn't pedal up the hill to his house . . . He didn't say much, but he was a nice chap. Shy. I don't think he'd as much as spoken to a woman . . . Not bold but tough when it came to politics. He'd been in the Resistance . . . He made himself a library in the woods in a hollow chestnut tree.'

'. . .'

'He didn't suffer, apparently. Didn't see it coming. It was a good way to go. Some people hang on for years. My poor father spent ten years in bed, paralysed. I think you're better off going suddenly, don't you? Boom, and it's goodnight from him! You arrive up there in better shape. No time to go off.'

'Do you believe in that?'

'I believe in the heavens because I can see them up

above me. But as for knowing whether there's anyone up there, well . . . *I* think we go to feed the maggots when we die. Which is good news for fishermen. During the war there was this chap in the woods whose stomach burst open. The body had been in there a month. They found him because of the heat. He was full of maggots. And he stank . . . Those little buggers clean you out. If it'd taken much longer, they'd have polished him off completely. When people go on at me about heaven, I picture that chap in the woods. It didn't look like *he* was in heaven, with those things wriggling about where his eyes had been. It was as if he was looking at you. Like his eyes were moving.'

A long silence. A sigh.

'Perhaps it's best like that. It'd only be annoying to get old . . . And your teeth go bad. The ones I've got left rattle about so much that they'd fall out if you gave me a good slap on the back. Soon I won't have any of my own left. Just the bought ones. The dentist took three out the other day. Three at the same time. That hurts! The next day I was breaking stones on the railway, and the pain! It felt like someone was taking a mallet to my jaw. I don't know what he was thinking, doing so many

all at once. He pulled out all of the lower teeth of that Italian who lives on the square. You know the one I mean, the mason. And he's still in pain. A specialist in Limoges told him it wasn't worth all those roadworks just for a bit of swelling in his gums. He gave him some ointment to rub on. I'm worried now that the same thing's going to happen to me. He gets them out easily. He's got the muscles for the job. Oh yes, he's got muscles all right. Hup! One pull from his pliers. It feels like he's pulling your whole skeleton out through your mouth, though. You don't exactly feel great. He said: "I'm not going to give you an injection. You're a tough old bird." The back teeth – the molars – have hooks on them like turned-up spikes. Bit like a turnip. They bled a fair bit. He said: "Grip on to the seat, but don't break any of my equipment." And then he took three out, one after the other. One of them had no grip, and the next one was rotten, but the third one didn't want to come out. My arse was six inches off the seat by the end. He's a strong chap . . . He says he's going to take out all my lower teeth. "It's going to hurt a fair bit, but afterwards you'll be right as rain," he says, just like that. You know,

he's right. He's making me a whole set. It looks like a rat trap . . . The pension fund pays. Us railwaymen are entitled to free travel and free teeth. "You'll be able to travel with a smile on your face," he says to me. Sometimes I think it could have waited a bit, you know. But you try telling that to a dentist when he's got his hand in your mouth. Anyway, with my new set, my teeth won't look a mess any more – no more stumps! It'll be better. The wife'll be proud of me when we go to Nice and I can laugh when I see the sea.'

*

In the photo, he has his new blue overall on, stiffly ironed. He's holding his jacket half-open by its lapels, like shutters on a bedroom window. He's looking at the sea. His wife – 'the wife' – is wearing a longer dress than usual, and is holding her bag by its strap. Her high heels make her a head taller than her husband; she too is looking at the sea, over the top of his cap.

*

He opens his mouth to reveal a miniature keyboard.

'They're brand new . . . I've just come from the dentist's. They're good. Nice and regular . . . They say they take a bit of getting used to.'

'Now that you've had your repairs done, you can go to Nice.'

'We go in the autumn. That's when they do the special offers, particularly for railwaymen. I got the address of our boarding house from *Rail Life*.'

'*Real Life?*'

'No, *Rail Life*. Life on the railways. It doesn't cost anything to get to Nice with the wife. We're entitled to free travel coupons. Here, look at this photo from last year.'

'That's you, all dressed up? And there's the sea in the background.'

'It's beautiful. It's true that there's not much to look at, but it's beautiful. And blue. It's so big . . . Beautiful.' *He makes a circular gesture with his arm.* 'The hotel's nice and comfortable. We've got our routine. We arrive, leave our cases and go out for a walk straight away. Then we come back again. You can see the station from our room. It's close enough to walk to the hotel when the train gets in. The owner remembers us from one year to the next . . . It's not expensive for full board. They do a special rate for railwaymen. The owner used to work on the railways before he opened the hotel. It's nice and

clean. We eat well, even put on a bit of weight. It's good if you're keen on fish. I like everything, I'm not a fussy eater. They include a quarter-litre of red wine in the price, but I don't touch the stuff. Just a drop or two in the bottom of my glass, so that no one can say I'm not drinking. We stay two weeks . . . But you know, after ten days . . . It's funny, but I get bored doing nothing . . . Plonk yourself in front of the sea every morning . . . At the start it's all right, but after a week of the sun beating down on your bonce . . . Sometimes it could almost knock you to your knees. And you know, the thing is, there's not that much to see. Once you've seen the sea and the promenade, the palm trees and all that, well, you go back to your room . . . We go every year. They keep the room for us. It keeps the wife happy. She comes from somewhere hot, you see, she was born in Algeria. I can't get used to it, but it's a change. As good as a rest. We take a walk on that avenue along the seafront. I can't remember what they call it.'

'The Promenade des Anglais.'

'That could be it. And we look at the other people. There are lots of old men and women. With some of

them it would only take a little push . . . Me and the wife go for a stroll, first in one direction, then in the other. We do that two or three times and by then it's time to eat. You can help yourself to the starters, eat as much as you want. The first time, I took too much, but after that you get tired of it. But it's nice, and it's well prepared. Then we have our siesta. I don't know if it's because of the sun down there or because we're not doing anything except trailing around, but I fall asleep on the bed. We take our shoes off and sleep with our clothes on. We wake up at five and have another turn on the promenade. Look at the waves. There's a bit more of a swell . . . Well, it depends. Sometimes it's so flat you'd think there's nothing underneath at all . . . We look at the ships passing out at sea. Just sit on the wall and watch. No one speaks to anybody else. It's calm . . . Except one day this lad asked me to give him a hand starting his car. We got it going and it blew smoke all over my trousers, and then – you're not going to believe this – he thanked me by sticking his arm out the window like this . . .'

'No! He gave you a *bras d'honneur*?'

'Yes, just like that! Anyway, it only happened the once.

Normally people don't talk to you. They leave you in peace. No one speaks to anyone else.'

He looks at his watch.

'At home it's just like Nice – when it's time to eat, it's time to eat!'

*

'There's something that's been bothering me that I've been wanting to ask you. What's it *for*? I know it's supposed to look beautiful, but where's it meant to go? . . . I've just been wondering. You need space for a big thing like that, so you can step back and look at it. So it has to be the right sort of house. Well heated and that. Not just any old where. Somewhere a bit special.'

He is looking with his head bowed.

'It's beautiful . . . if you like that sort of thing. It's all a matter of taste, isn't it? . . . Some people would find it beautiful. I can't tell. Because I've been watching you do it, I'm starting to think it's beautiful. But don't ask me why. Because it's not *for* anything and it's a lot of work, I've been saying to myself, "It must be beautiful." But what does that mean? . . . I can't really explain it.' *He ponders.* 'It gives you pleasure to look at. I can't say more

22

than that, I don't think. The pleasure comes from looking at the colours. It's easier to say what *isn't* beautiful. Now, take that chap who got chopped into pieces by the train yesterday. Did you hear about it? The 13.40 from Paris gets in just before the express that goes *to* Paris. Anyway, the two trains crossed in the station. Only the express didn't stop. This chap gets off the Paris train on the wrong side of the track and gets himself chopped up by the express. No two ways about it, it completely mangled him. They found bits of him as far up as the level crossing near the doormat factory. That couldn't have been a pretty sight. Now, you couldn't call that beautiful. It gave him a proper going-over, poor bloke . . . Well, there's no comparison. It's the same words but they're things that have nothing to do with each other. Hmm . . . Poor sod . . . But a painting's not like the real thing. It's how it's made that counts. I can't explain it. You're the professor, not me. I'm happy to watch you. Anyway, I make beautiful things too. Take a look at this.'

'What is it?'

'A lettuce.'

'That's a lettuce?'

He laughs.

'You see, you're not the only one who makes beautiful things. This is my work.'

'It *is* beautiful.'

'It's for you. I'm giving it to you. I've got a patch full of them. And I can't eat them all. They'll have bolted by next week.'

'Thank you.'

'I'll leave it here for you.'

'It's a real beauty.'

'Beauty means things that give us pleasure to look at. It's simple . . . But what you do is more complicated than a lettuce.'

'Perhaps it's not as beautiful.'

'I think it's *more* beautiful. Even if I can't say why. With the lettuce, it's because of its crisp white centre, and its size. Whereas with your thing there . . .'

A long pause.

'I'm off for my soup. See you tomorrow. Take care.'

'Thanks again for the lettuce.'

'White coffee's making me feel ill. I can't digest it.'

'Try tea, then.'

'I've never had tea. They say it's easier to digest than coffee.'

'It's easier to digest than *white* coffee.'

'Is that so? . . . I can't say I don't like it, because I've never tried. It's what they drink . . .'

'. . . In England.'

'It can't be that bad. They aren't any dafter over there than us.'

'. . .'

'I'll definitely try it. Where do you get it?'

'Same places you get coffee. In shops that sell coffee.'

'I haven't noticed.'

'You just have to ask.'

'I can certainly try. What's the worst that can happen?'

'You'll look English.'

'That'll be the day. My God!'

He laughs.

*

'So, how's your tea, then?'

'It's something different.'

'Do you like it?'

'It's one of those things . . . you have to get used to.'

'Are you embarrassed at looking English? It's very stylish, you know.'

'That's as may be, but on the railways I'm the only one who drinks the stuff.'

'Did you tell them what you're drinking?'

'No, they'd think I wasn't quite right . . . What do you call it? . . . Effeminate.'

'Someone who doesn't drink wine.'

'To hell with wine! I only drink water. Though I haven't always.'

'Tea won't do you any harm.'

'The others don't say anything, but you know how it is . . . But I'll drink it anyway . . . I can digest it easily, that's the main thing. All the same, tea isn't that nice. It tastes bitter.'

'That'll be because you're making it too black, like coffee.'

'It's the wife . . .'

'It should be light, like tanned skin.'

'I'll try that. Maybe we are making it too strong. But when you don't know . . .'

'You can put milk in it. Or lemon.'

'I might try a drop of milk. Why do they call it Elephant Tea? Is that the make? You can't understand a thing in those adverts. It's the same on the telly – you see a bar of chocolate and a naked woman. You don't know whether they're advertising the woman or the choco-late . . .'

'. . .'

'Tea's a bit exotic for us . . . whereas wine . . .'

'. . .'

'I just look at booze from afar. I can't drink it any more, but in my time I drank enough to fill your barn. Poured it down my throat for years. There were days when I'd roam all over. I had a bike that knew my ways – it'd get me back home like a horse that knows its stable.'

'Why did you drink so much?'

'I don't know. It was like I needed to feel numbed. I only felt OK if my tank was full.'

'What about your wife?'

'She didn't like it much. She didn't say anything, mind. She'd put me to bed and leave me alone in the dark. It would have killed me if I'd kept on at that rate.'

'What did you drink?'

'Red wine. Ordinary cheap stuff in plastic bottles. I needed it. I'd have drunk anything as long as it was wine. I don't know why when I think back on it. And I don't know any more how it began. It must have happened one day without me realizing. In the end, I wasn't good when I drank but I was worse when I didn't. It was like there was this hole in the pit of my stomach that made me feel a sort of disgust. Not really like wanting to be sick. But I had no appetite for anything. Not work, not nothing . . . It was the wife I felt bad about. It was seeing her that saved me . . . her and the kids . . .'

There's a silence, followed by a sigh.

'I bought a scooter with some money I'd saved. At the start, when I felt thirsty, I'd go out on it. All over the place. I nearly broke my neck more than once. When I think back . . . Then one day the wife said to me – nicely, without getting cross – that she would leave me if I didn't stop, and anyway the doctor had said that I was going to

kill myself. I listened to her and decided to stop. From that moment on, I haven't touched a glass of wine. Except in Nice. I don't dare say I don't drink – so I do wet my whistle when we're there so that we look the same as everyone else. But nothing on Earth could make me drink a whole glass. It's poison. Filthy stuff. I'm well rid of it . . . Now I don't drink any more, but when it's time for my soup I get hungry. And when it's time, it's time. So I'll be off.'

I returned at the beginning of July after several months away.

'Did you have a good journey?'

'Yes, thank you.'

'Are the children well? And the wife?'

'What about you?'

'Fine, thanks.'

'Everything's fine with me, too, thanks. We had a good journey – we did it in six hours.'

'Six hours!'

'Yes, just six hours to get here from the Porte d'Orléans.'

'That was quick!'

'Yes, we didn't hang about.'

'So everything's fine?'

'Yes, fine thanks. The countryside looks beautiful. The grass is cut. The barber's been . . .'

'I've got a surprise for you!'

'Oh?'

'Your country priest's garden. It's ready.'

'You've been doing it while we were in Paris?'

'Yes, I'm the boss round here when you're away. You'd talked about that garden, and I said to myself: "I'll do it as a surprise for him." I began with a lettuce patch, and then I planted the leeks. Then I remembered that the wife – your wife, I mean – liked green beans. And bit by bit the garden got bigger . . . Now we need to put a wire fence around it . . .'

'We should sow some marrows and pumpkins, and mangetouts, too. And plant some gooseberry bushes.'

'Come and see. Come and see your courgettes, they're just starting.'

'My, it's a real garden!'

'Just like you described.'

'A country priest's vegetable garden.'

'It faces the rising sun. It gets the first rays of the day. It's a good site.'

'We need a stone wall for the snails. And for somewhere to sit down . . .'

'Come and see the courgettes. Do you like courgettes?'

'Hmm, not really. They don't have much flavour.'

'But that doesn't make them all bad . . . Look. Aren't

they beautiful? It's as if they're growing fingers . . .
They'll give a good crop. And they grow quickly. If you
stand still, you'd swear that you can *see* them growing
before your very eyes, from one day to the next. I know
that if you look at them long enough . . .'

'It's like praying for rain. You just have to be patient.'

'You'll see tomorrow. They'll be everywhere and you
can eat as many as you like. We'll let one get big.'

'My father managed to grow one that weighed 180
pounds. We put it in the shop window. It was during the
war so there was nothing to sell. We put everything in the
window . . . Don't you think that one there has grown
since we last looked at it?'

'Maybe . . . they're speedy . . . I've had my eye on that
little green one and I reckon . . .'

'Yes, I think so too . . .'

'You'll see tomorrow.'

'Anyway, they're beautiful . . . All those fingers.'

*

'The lettuces are bolting. There's nothing we can do
about it. Some years it's like that. All of a sudden the
game's up and they bolt. You need to eat them while

they're still round . . . And don't let your marrows get too big. They're better when they're small. Mind you, I don't care for them much either way. Apparently, some people eat them raw, too . . . What are you looking at there?'

'Nothing in particular.'

'It won't rain tomorrow either. The sky's too clear.'

'How can you tell?'

'I just know it won't rain tomorrow. You'll see.'

'Ah, you're keeping your weather secrets to yourself.'

'And you don't say what you're looking at when you're drawing.'

'I'm looking at the shadows. When they turn bluey-black at the end of the afternoon down by the little bridge over the Brezou, below old Marie-Pompon's pond, it's a sign that summer's coming to an end. You can tell autumn's on its way.'

'You forecast further ahead than me!'

'In August the blues become sharper, the shadows cast by the trees turn deeper, and shapes are clearer.'

'I'm listening, but I can't say I understand it all.'

'If you want to make a picture more alive, its elements more connected, you have to soften the way you look,

like Bonnard did – look as though through the eyes of a child, without trying to give everything a name. That way you see the continuities and the transitions better. The world becomes *one* and you feel good to be a part of it.'

'What on Earth are you on about now?'

*

'You'll have to pull up the leeks that are left. If you let them dry, they'll get as stiff as boards and the worms'll get them.'

'Some days those marrows get on my nerves. Especially at dusk.'

'What are you looking at over there? The Post Office van?'

'No, I'm not looking at anything. I'm just looking.'

'You're making pictures in your head.'

'Perhaps.'

'There's a nice clear view from here. You can see who's coming. You breathe better when you're a bit higher up. You see the sunrise and the sunset, and even though you're high up, you're sheltered from the wind. There's a bit of air. When there's a storm it doesn't half make a racket.'

'In short, on this hill, I've got everything: rain when it rains, warmth when it's sunny, rain and fine weather like everywhere else. You think that it must be like that, as it can't be otherwise.'

'It's like that, no two ways about it. When it rains it rains, and when it's the sun's turn, make the most of it. But it's not like it used to be. Now it either rains like it's never going to stop, or else there's a drought. In my garden at home everything's dried up. There are cracks in the earth that you could stick your finger in. The soil's as hard as rock. My pick just bounces off it. Go and try to pull up the leeks! They'll come away in your hand like a lizard's tail. There was a bit of a storm which softened the earth a bit but it didn't penetrate. An inch below the surface it's still as hard as concrete. The plants are suffering this year. So are the animals. Still, we've got the tap. Just as long as there's water in the tap . . .'

*

'Are you going on holiday this year?'

'Yes, most likely we'll go to Nice as usual in September or October. The wife's got used to Nice. But like I said, after two or three days I've had enough of

waves and boats. And it doesn't rain much. I prefer it here. You don't have the sea, but the sky's always changing. Clouds are like waves, but there's more variety to them. And the rain's good for the plants . . . It's the same all over – you like the place you're born. Don't you think that the Eskimos who live in the dark and the ice all year round would be up and off if they hadn't been born there? Travelling lets you see other places, but it's good to get home again. You appreciate it more afterwards. In the end, you're just as well off at home and it costs you less. Mind you, Nice doesn't cost all that much . . .'

'Camping doesn't tempt you?'

'I've never tried it, but sleeping on the ground at my age would play hell with my rheumatism. I don't see why I'd want to go and lie on the ground. I prefer my own bed. You need to be young for camping. My son-in-law, the one who works in a garage, kitted out a van as a 'camper', as he calls it. They go away in it and stop wherever they fancy – in car parks, at the side of the road, in squares, anywhere at all. They've got everything in the camper – gas for making soup . . . there's even a toilet. It isn't big' *(he demonstrates with his arms)* 'but you

can take your time, you're at home . . . He's a smart one, the son-in-law. At the start the police used to ask him for his papers because you're not allowed to just park a van and sleep wherever you like. But because he kept the adverts on the side they think he's a rep and he's sleeping in a hotel. That saves them having to pay for camp sites. On the side of the van it says "Akileïne" in big letters. That stuff for your feet. The Old Bill run after him to get free samples. That costs him!'

'All he has to do is write "Cod Liver Oil" instead.'

'Their van's nicely kitted out. They came round on Sunday and we had a coffee, sitting on the bed. It's nice. A bit of a tight squeeze, but nice . . . Anyway, it isn't better than on the estate. It's not as good, I'd say, but at least you get to drive around. You have to be young for that . . . On the whole, we're not too badly off up there on our estate. The view's good and it's nice being in bed in the evening after our soup. But in the morning I'm up before the sun. I drink my tea and watch it come up. I wait on the balcony for it to rise above the valley. Often there's mist at the bottom. It's what *you* would call a land-scape. But landscape's when nothing's moving when you

stop to look. I think that there has to be some move-ment, something happening, otherwise I don't look. And anyway, there's always something happening if you look closely. I love watching the sun come up and the mists clear. I could watch that till the end of time – it's better than cinema. It's real. You have to know *how* to look. And be patient. The son-in-law asks me what I'm looking at. "I don't know," I tell him. And it's true: I don't, exactly. But to try to explain to him, I've thought about it as I drink my tea. It's like I'm watching time moving. But try and explain that to a chap who's never watched anything but the television and films. You know, I watch TV too, but that's different. It's fine for a story but not for things that move slowly. It needs everything to move quickly. They're always shooting at each other. I've had enough of war. Even hunting makes me sick. I like eating rabbit and hare, but I don't like killing animals. It's better to leave them alone, don't you think? Look at the rabbits that come to eat the lettuces. I like watching them hop-ping around.'

'It's just moles you don't like.'

'Moles are different. They make a right mess. Leave

them to it, and they'll turn your meadow into a battle-field. And you can't see them. I poison them. What you can't see . . .'

*

'How are you?'

'Fine. How about you?'

'I'd be fine, if it wasn't for the son-in-law . . .'

'The Akileïne son-in-law? Is he ill?'

'No, the other one. The one married to Lulu, our eldest. The one who's in Paris, in the suburbs. You remember Lulu? Her husband was a security guard in a supermarket. Well, he's lost his job. The supermarket's closed down. Of course, he'll get a little bit of money, but all the same I don't know what things are coming to. The way they turf working people out . . . When there's no one left in the factories and workshops, who will there be to buy anything? It's all very well making more things, but what'll they do with it all if they can't sell it? The problem with the son-in-law is that's the only thing he knows how to do. I'd have done anything at all to work at his age, to earn my living. Wouldn't you?'

'. . .'

'Young people get used to having a salary and if they get the sack, they're at a loss. In my day, there was less of this studying, but we learned a trade so that we could earn a living whatever happened. We knew how to get by somehow . . .'

'What job would you like to have done if you'd been able to choose? I'd like to have been a doctor or . . .'

'I would've liked to be a farmer. I'd have kept animals, especially sheep, and I'd have had a garden with flowers in front of the house. Dahlias. I know about farming. I'd have enjoyed having a farm. I'd have extended it as the children grew up, and knocked up some lean-tos to put them in. I can put up just about anything. Of course, I'm no artist. We used to gauge everything by eye – it was all a bit skew-whiff, never quite straight perhaps, but sturdy. It was strong as pegged beams.'

'I'd like to have been a psychiatrist.'

He laughs. 'Those doctors for mad folk? It can't be fun looking after them every day. I wouldn't have liked that, but I can't quite say why not.'

'It isn't catching.'

'Hmm, perhaps, but it isn't nice to see. There was one

on our estate. He went on like an animal. Shouting and pulling at his sleeves and pacing about like a bear . . .'

'And what else would you like to have been?'

'A rag-and-bone man or a scrap merchant. I'd have had cars and motorbikes piled up in a field, especially bikes, and I'd have taken them apart to repair them and sell the parts. I'd have had old car bodies, one for my office, another for the chicken coop, and a third one for my tools and seeds. And to stop it looking too much of a mess, I'd have scattered climbing-flower seeds around the old cars. Nasturtiums would do the trick. But it's too late. You can't have your life over. You have to be born rich, like the people who come into the world with a chateau and a car and suchlike. Mind you, if I'd had money and a chateau, perhaps I wouldn't have grown nasturtiums round the old cars. The lady of the manor wouldn't have liked it . . .'

'Your lady . . .'

'My lady will be waiting. I'd better be off. I like having a natter, but it makes me late. I'm off.'

<p style="text-align:center">*</p>

'I wanted to ask you something . . . about the stakes for the green beans . . . Now that I've cut them for you, and

the beans are finished, what are you going to do with them? Will they just go on the fire? If you don't mind, do you think I could take a few for the beans in my garden?'

'Take as many as you want.'

'I'll return the favour.'

'You should feel at home here.'

'So you've said . . . And you're right, it is like being at home. When I'm here working by myself, I think about that. About everything I do here . . . and I act as if I'm at home . . . Even so, I'm at home and at the same time I'm not. If I think I am, that makes me want to do things right . . . But you could knacker yourself like that . . . I'm not saying this because I'm not happy here – quite the opposite – but I think that it's better not to muddle things up. This place is yours. I work, and you pay me. If we enjoy talking to each other, so much the better. It's a bonus. But you're the boss and I'm the gardener. And if you didn't pay me, I'd still come to see you just for the pleasure of it, but I wouldn't come so often . . .'

'Ah, come the revolution . . .'

'Hmm, that won't necessarily make life any easier. Lettuces will still be green . . . Mind you, a red let-

tuce . . .' *A pause.* 'All the same . . . I'll have your house and garden and have you slung on the estate.'

'I'll have a good view of the town. I can paint the sky.'

'I'll be a farmer, an old-style one . . . But if the farm belongs to the state, you won't catch me doing a stroke of work. Anyway, even if you worked flat out, you'd still need help with it.'

'You want to create a collective farm, comrade.'

'And you'll have to muck in too, you realize.'

'You need bosses in the offices, though.'

'Offices for a little bit of land like this! It's me who'll be feeding everyone. There'll have to be a request put in for every single seed, and every spade . . . The moles will wreak havoc while we're waiting for the form to arrive to request mole poison . . .'

'The hope of revolution makes life more bearable.'

'Well, it annoys some people. That's always the way of it. Mention of it shuts them up. There are some people who'd treat you like dirt if you didn't stand up for yourself. It's worse than contempt – it's as if you didn't even exist in their eyes. And yet I exist the same as them, not more and not less. This is a republic and that makes me

a citizen just like them. They're elected to represent the people, including me. Getting elected doesn't turn someone into a boss. He's just the same as a door-to-door salesman, a delegate . . . In the meantime, I'm going to have my soup . . . I reckon there's a storm coming. I'd better look sharp. My helmet doesn't have a visor.'

Before he puts his helmet on, he reflects for a moment.

'Red lettuce – that's not bad. Red lettuce!'

'They do exist. But they're bitter.'

'You're up early this morning.' *There's mockery in his narrowed eyes.* 'Up before the sun, no two ways about that.' *He points to the black sky.* 'Filthy weather. I was planning to rake up the leaves in the field, but the wind's blown them all over the place. I'll come back this afternoon . . . It's going to improve. They said on the radio it'd be sunny. Doesn't look like it, but they're not often wrong.'

'Isn't your scooter dangerous in weather like this?'

'I'm careful. And I've got good brakes. But sometimes, no matter how careful you are, if you're going to fall off, you'll fall off. I came a cropper the other day. At the bend after the Carderies bridge. I'd been fishing. The trout bite down there. They throw all the rubbish from the abattoir into the river – guts, whole cows, pigs – it's like a salting tub. It's not that clean, I grant you, what with the strips of meat that come off in the current, but it attracts the trout. I usually catch a few. And they're good. Of course, I don't let on to the wife where they're from. Sometimes we come across . . . bits, while we're eating . . . but look at me . . .' *I look at him.* 'I eat a kipper

45

every day. If you believed it had an effect, I'd have fins coming through by now. Mind you, it's true my mug looks a bit . . .' *He laughs.* 'But I was like that before.' *I laugh too.* 'On the estate and in town, there are plenty of folk whose faces would make you wonder what they'd been eating. The grocer looks like a bulldog and growls like one. He's as charming as one, too, what with his rosettes, his little curls and his purple snout. And the baker's wife – if you look at her face, you'd think she was one of those fancy breeds like the jeweller has. And the fire chief with that jutting jaw of his must have eaten some crocodile. If you look hard, almost everyone looks like some animal – it just depends how you catch them and what they're wearing. Clothes can throw you off the scent a bit.'

'And what about the priest?'

'Oh, I don't mix with him. They say he's decent enough. Stocky, well-fed chap. Anyway, some of them are all right. It's a job like any other. I don't believe their stories, and I can still remember the priest who beat us with a stick at catechism.'

'You're not keen on priests, then.'

'Oh, I'm happy to live and let live, as long as they do the same . . . But how did I get on to that? I've lost the thread. Oh yes, on the bend at the Carderies bridge I came off my scooter – I hit some gravel and it skidded to the side and I went with it. I grazed the whole length of my leg. Have a look. I almost needed extreme unction . . .'

He laughs.

'It looks like the remains of a kipper.'

He looks.

'That's true.'

He laughs, and looks again. I point out to him the head, the eyes, the bones, and the tail.

'I hadn't noticed, but it's true . . .' *he says again.* 'It's all there.' *He seems perturbed, though he's laughing.* 'I'm off. I'll take care not to decorate my other leg with a shark. It might eat me up . . . Bye!'

He puts on his helmet, and gesticulates to indicate that he can't hear now. His voice is muffled by the helmet.

*

He comes in without making a noise 'so as not to disturb' me. He takes up his position, in his blue canvas jacket, his feet apart,

and his hands behind his back. I know that he's behind me. I also
know that he'll speak after giving a cough, so as not to take me
by surprise.

'I came to tell you that I'm not coming today and I
can't come tomorrow either. I'm going fishing.'

'You've got an appointment with some fish?'

'With one particular fish. One I know. He's a carp who
lives in the silt opposite the private fishing area just
under the war memorial. I'm giving you the detail
because you don't fish. He's a beauty. We know each
other by now. That has an effect. He's pulled my rod to
pieces, even its tip. The last time I had him in the land-
ing net, I got him out, and he gave a flip with his tail and
broke the thing. They're crafty blighters.'

'Why do you have it in for him?'

'I want to eat him.'

'Are you sure? If you added up your time, you'd see
that your fish is costing you a lot.'

'Possibly . . . but I love fishing. Don't ask me why. It's
like a fight. Someone always wins. Perhaps we're all
animals when we hunt and fish. Prehistoric. It's simple –
you set your bait, and you wait. And you know your prey

is waiting too. It's the same whether it's a fish, a tiger or an elephant. When you've got the fish on the end of your line, you want to insult him, hit him, and then give him his medal like someone you've beaten. Anyway, he gets his medal on the plate, when you decorate him with parsley and slices of lemon. Of course, while you're fishing you don't really think about that, but you get me talking . . . Most of the time you don't think about anything at all, you just look at the water. If you look down into it a bit, it stops you falling asleep. But when the river's dark like a sheet of metal, it sparkles and you can't see anything in it.'

'What do you see when you can see into it?'

'Pebbles, fish, things moving about, things you imagine you can see without being really sure.'

'A bit like looking through a keyhole.'

'Maybe. But it doesn't feel the same . . . It's true that it catches your eye as though there were something to see, although you know that you're not going to see that much. Sometimes with my big fish, you see a movement. A flash like a blade being turned over . . . or a bit of white rag . . .'

'Or a petticoat.'

'Everyone sees something different. You see petti-coats. I see rags. I'm off to my appointment. If I catch him, I'll invite you to come and taste the soup.'

*

'The lettuces are bolting. It's been too hot. And then there was that little bit of rain yesterday . . . you need to cut them. In two days they'll be three feet high, and that's no good. You've got some nice ones at the back of the patch. Here, look at those.'

'We can't eat eighty lettuces all at once.'

'No, but by tomorrow they'll be goners.'

'I'd like two for lunch, and you can help yourself to the rest.'

'I've got some in my garden by the river. They could be two hundred feet high by now.'

'We're spoiled.'

'What about the courgettes? Don't you like them?'

'Not much. When they're boiled, they're a bit . . . you know . . . What about you?'

'They don't have much taste, but I like watching them growing. They've put on a bit of weight since the last

time I was here. Courgettes make me laugh when I see them growing. They look like they're having a joke, the way they grow. Like curlers on women's heads on Sunday mornings. You see the women running across their balconies on the estate. They act as if they were naked just because they're in rollers. Galloping from one door to the other. Yes, they're just like rollers.'

'And cabbages?'

'A nice cabbage is beautiful.'

'Why is it beautiful?'

'It's beautiful because it's beautiful . . .'

'Now, there's an argument . . .'

'What I meant was . . . Look, every time we talk about what beauty is, you ask me what it means. In a cabbage it's the colour, the shape of the sides, how round it is. As if it was going to burst. When I was a kid, they used to say that children were found inside cabbages.'

'Nowadays you can see a photo of the baby in its mother's stomach.'

'Back then, everything told a story – the sky, a storm, the snow, a flower, a bird, the things we ate. A storm was God shifting the barrels around, or getting angry. Snow

was God plucking geese. A bird announced a new season, or told you what the weather was going to be like. That way, things had a meaning. Nowadays you can't understand anything that happens to you. There's no rhyme or reason. A vegetable's just a vegetable which you see when it's wrapped up. And a man's just another thing wrapped up for sale.'

'You're a real philosopher.'

'While we're in the garden you should have a look at these beans, the yellow ones. They're ready for picking. If you wait, the strings will be like old rope. But they're good at the moment. If you like I can pull up the plants and you can pick them as you need.'

'You're in charge.'

'What about the pumpkins? Have you seen them? That one there on the other side of the chicken wire is going to get big . . . the stalk that's feeding it isn't cut and that's the main thing . . . You mustn't cut the stalk or else it'll be done for.'

'Do you believe that there are babies inside pumpkins?'

'Babies, no. But a carriage, yes . . . I think your

kitchen garden isn't bad, but it needs to be bigger. You could have more potatoes and leeks.'

'Ah, leeks!'

'Yes, I'll plant you a row of them . . .'

'We shall have row upon row of them. Whole avenues of them, a park fit for the prince of leeks . . . And what about the herb patch?'

'I made you one. Where's it gone?'

'It's lost.'

'There was thyme. Where the devil is it? And chives . . .'

'Next year, I want you to grow—'

'Mange-tout peas, I bet!'

'Mange-tout *and* peas.'

'I've never seen them. You've told me about them before, but I've never eaten them. Find me the seeds and I'll do it. It's not difficult getting things to grow here.'

'My grandfather's garden was like this. Nice, neat paths.'

'You should tamp the earth down on the paths to make them firm. It'll make it more beautiful.'

'What does it mean, when a garden is "beautiful"?'

'That the vegetables grow well and that things are in order.'

'Ah, order . . . like a military parade . . . Do you find them beautiful?'

'I'm talking about the garden.'

'You were talking about order.'

'Maybe. When you do your paintings, you create order. From the muddle of what you see, you make choices. You tidy it up and it becomes beautiful when you can take pleasure in recognizing what it is, in working it out. I'm not the one who eats the vegetables from your garden, but it's beautiful when there's a good crop – it's like thanks for a job well done. If it was full of weeds, I'd have lost. It's like a dress on a woman – it makes her beautiful, but that doesn't mean you take advantage . . . That's just the way she is – you can look on it as a gift, or as nothing at all, or just how she wants to be for herself. And another thing . . . '

*

'I've swept up the leaves. The wind blows them all over the place and then you can't get them off the grass. I've swept them into piles.'

'Like little graves.'

'Then I'll burn them.'

'Are you going to burn them all together?'

'Weather permitting. As long as it's not too dry and not too wet.'

'If they're damp they'll smoke?'

'You'd smoke out everything for miles around.'

'And what if they're dry and there's a wind?'

'You risk starting a fire if it gets out of control.'

'I can help you contain it.'

'If there's a wind, there's nothing you can do. It'll escape and spread like the very devil.'

'The weather's just right today.'

'I reckon so . . .'

'So, let's get on with it.'

'Take care not to burn yourself. Shift a bit! See where the wind's coming from? You're going to get your eyes full of smoke . . . Do you want to do a picture of that?'

'Perhaps. If I can open my eyes . . .'

'Don't get any closer. You're going to take the fire with you!'

'It's as if we're burning the dead.'

'I'm just making smoke.'

*

'I've come to say goodbye. I'm going home early. Lisou – our youngest – is ill. I don't know what's the matter with her. The doctor's coming. She's got a temperature and she's having convulsions. She's groaning and tossing and turning. I reckon it's worms. But the women have put a garlic necklace on her and sewn a letter into her shirt. And that should do the trick, so they say.'

'What sort of medicine is that?'

'Witchcraft.' *He laughs.* 'It's like in Africa, but try telling the women that! I prefer to say nothing and slope off. My place is in the garden. I leave the children to the women. I don't know anything when it comes to illness. Women are used to it.'

'What's a garlic necklace?'

'It's to get rid of worms.'

'It also gets rid of vampires.'

'Might well.'

'Garlic stinks.'

'That's true, especially when it's hot. Lisou hasn't

worn her necklace for a while, since it turned warm. The teacher at her school took it off her.'

'Do you really believe in all this stuff?'

'Hah!'

'What about the letter?'

'It's written by a woman who knows about all that sort of stuff. A prayer, most likely. We're not supposed to look at it. It's sewn into her shirt on the inside. It must be touching the skin.'

'And that protects her from . . .?'

'Convulsions. And worms.'

'Do you think so?'

'I don't think anything. It's the women. If I say anything, I get my head bitten off. And the letter doesn't do her any harm. If it does some good, so much the better. It doesn't cost any more than the doctor. Last time, it was almost like the doctor had never been. He took a quick look, but he was hardly in till he was out again. He got her to cough, and looked in her mouth with his torch and a soup spoon, and then he put on his ear-trumpet thingy, but we didn't catch what he said he heard because he mumbles. In the end, he wrote a letter, too. He gives

you a whole pile of things and if you weren't ill before, you're certainly ill afterwards.'

'So you could say you're trying both systems.'

'You could do.'

'Do you believe in it?'

'I do and I don't. It's like lots of things: when you don't really know, the best thing's to do the same as everyone else. Or pretend to. If you start to think for yourself, other people think you're a bit loopy. I act like I believe in it. But in the end I know it doesn't really do that much.'

'You believe without believing.'

'You could say that. But it's like your things there.' *He points to the paintings.* 'You believe in that. For you they're real, sometimes more than real, and yet it's a piece of paper with pencil on it. You know that it's paper and pencil, but you need to believe in it to do it.'

*

He has a way of pointing things out at a distance. He keeps loose chippings in his pocket, which he throws one by one in a particular direction. If he hits the target, he says: 'It's that branch there.' So far, so good. If his aim is less accurate, he makes a verbal correction: 'It's the branch above that one.' Or 'the fork

below'. He uses the same technique in the field to talk about a bump that needs levelling out or a hole to be filled in.

*

'Just look at your lime tree.'

'The leaves are nearly ready for picking.'

'That's not what I'm looking at.'

'What are you looking at, then?'

'Can't you tell?' *A silence.* 'Well, I was looking at the tree and thinking that the rock underneath means it's got such shallow roots that a gust of wind, a strong one, would uproot the whole bloody thing and ruin your roof. It's too near the house.'

'Do you think so?'

'Its roots go right into the middle of the field. They can't go deep down into the soil, so they're spreading out. I came across them when I was digging down looking for moles. What you need to do is make holes in the tree's canopy so that the wind can't get hold of it. We'll cut the branches here. Then the one above that, and so on right to the top. With gaps in the foliage, you see, the wind blows through, so it doesn't bend. It offers less resistance to the wind. The other solution is to do what we did with

59

that tree over there. We could cut it like that. It comes to the same.'

'I prefer your first solution. The tree by the kitchen with its stumpy branches looks like it belongs on a station platform.'

'That gives new growth in clumps, so that the wind can't get so much purchase on the branches. It's tidy and it's safer. The stumps are solid and the thinner new branches let the wind through.'

'It's fine for the railways, but here . . .'

'Well, if you don't like it . . .'

'Don't take offence.'

'One day your lime tree's going to crash into your house. The wind will uproot it and it'll smash into your roof.'

'Is that a curse?'

'No, but . . .'

'You know, you mustn't hold it against us, we have our little ways . . . It's like that hawthorn you cut . . .'

'Hawthorns are horrible.'

'It was a hundred years old! And then there's the barberry bush that you turned into a gasometer . . .'

'. . .'

'. . . And the box tree in front of the house that you cut in the shape of a water tower for steam engines . . .'

'It makes it neat. But you're the boss. If you don't like it . . .'

'I think I'd rather you cut a few branches out. The lime tree's magnificent. It's wonderful eating in its shade, and it smells so good.'

'Whatever you want.'

'. . .'

As he goes off, he repeats: 'Whatever you want.'

In winter, it's pitch black by six o'clock in the evening. I'm holding an electric lamp which gives poor illumination, a pale circle of light that sometimes goes out.

'Bloody thing's got a dodgy contact,' he says as he digs.

I can hear him in the dark, panting, sighing and making 'Ha!' noises by way of encouragement.

*

'Hold the light up properly. I can't see a thing, digging in the dark.'

'There are lots of stars, yet they give no light at all. They're no better than the lamp. My arse is freezing sitting here like this . . .'

'Digging's keeping me warm.'

'God! Have you seen all the stars?'

'Mmm, there are a lot of them. I can see them fine. I don't know anything about them. If you look up at the sky for too long, you'd think you were going to fall into it. You don't realize how far away they all are. You can't grasp it. They're so high up . . .'

'Do you want me to do a bit of digging?'

'No, no, you'd chop your foot off. Just hold the light up.'

'If we get caught stealing a tree, how long will we get?'

'We won't get caught.'

'But if we did?'

'Hold the light for me and look at the stars. That'll take your mind off it. You'll see how nice this fir tree will be. It must be a good twenty foot high.'

'Ill-gotten gains never did anyone any good.'

'This will. You'll see.'

'You're making a huge hole. It's like a grave.'

'You've got to make sure you get the roots.'

'Are you going to leave the hole like that?'

'Don't worry, we'll fill it in.'

'It's like being on a dig.'

'Yes, like doing archaeology.'

He pronounces it 'Archie-ology'.

'You say archaeology with a "k", like Akileïne.'

He stops digging.

'I didn't know that. I've seen it in the paper, but I've never heard it said out loud.'

As he digs, he repeats. 'Ar*KAE*ology. Ar*KAE*ology. It's

certainly easier than archie-ology. It's a question of what you're used to, mind.'

'Do you think we'll find some treasure?'

'It's pretty thin on the ground. It's not enough just to dig a hole at the bottom of the first fir tree you come across.'

'What would you do if you found treasure?'

'I'd dig more holes all over the place.'

'Careful. I think you've got it.'

'The treasure?'

'The tree.'

'Don't worry. We'll wrap up the roots and load it into your car. It's going to stick out a bit. But you'll see – it's going to be a beauty. It'll be worth it.'

*

It's true. The stolen tree was worth it. It flourished like a bad conscience. In summer it absorbed the sun and stopped the roof of the house from getting too hot. It's now so tall that the smallest storm threatens to uproot it and destroy the roof. But it's a tough old bugger, with strong roots, and it clings on like anything.

*

'When you retire from the railways, the works council organizes trips for the old folks. Senior citizens' outings. We went to the caves at Padirac this year.'

'What's that like?'

'You go down a staircase to get to them. There's water at the bottom. It's all lit up. There are barriers to stop you falling. I spent my life on the railways imagining what other people were going to see, travelling along the tracks in their carriages. All I got to see were pebbles and rails. I wanted to see the world – people, caves, waterfalls, exotic countries, even the snows in the north.'

'And?'

'It's always different from what you imagine. But I hadn't imagined anything at all about Padirac, so I wasn't disappointed. The wife got cold down there. The sun's what she likes. She's got to have sun. At the bottom of the cave it's like a cathedral, but made of hardened sausages. We left yesterday morning and got back last night. One old woman was taken ill. Heart trouble. Someone said that she'd died at the back of the bus. We got back late. Still, it gives you a bit of a change to get out and about.'

'And what about the old woman?'

'I didn't find out. But I will. But they wouldn't tell us everything, otherwise no one would want to go on their trips.'

*

He takes a piece of parcel string out of his pocket. I look at it as though I have never seen such a thing before. Then he takes out some cotton string, plaited and tightly wrapped round a bit of folded-up cardboard. His knife is a Laguiole, which clicks when he shuts it. He clicks it twice.

*

'If you'll allow me, I'm going to give you a bit of advice: you should always have a bit of string in your pocket. Even if it's just a piece the length of your arm. And also a knife. This is a good one. It could slice through a hair . . .' *He cuts a piece of newspaper.* 'Hold it carefully or it will give you such a cut. Now, look at the string. You see, you should always have this much on you. That's the minimum. It can come in handy any-where. You can repair your shoe with it, or a suitcase, or a bag. And with a knife, you've got something to cut your bread. Kitchen knives and restaurant ones won't

cut through anything. But you see how that one cuts!'

'If I put all your kit in my pocket, my trousers will be down round my knees!'

'You can pull your trousers up before you go in anywhere.'

'You'd need a suit with shelves and drawers like a cupboard.'

'That'd be handy.'

'In Paris it's not considered stylish to have your trouser pockets full.'

'Ah, if you want to be *stylish* . . .'

' Hmm . . .'

'In any case, even in Paris, and even if you're being stylish, don't forget – a knife and a bit of string. Will you remember that?'

'I will.'

*

'You know what I'm looking for?'

'No.'

'A piece of wire. I only need a bit. Not too thick. I had a roll of it but I can't find it now. I must have taken it to my garden down by the river. I don't need

that much. Just a piece as long as my arm.'

'The problem isn't the length, though.'

'It's for the pipe. To adjust it where it connects to the tap. For watering. I also need a small piece about the length of your hand to make myself a claisp.'

'A what?'

'When a sack of potatoes has a hole in it, you gather the canvas around the hole and tie it together tightly with a piece of wire. That's a claisp. All wound round, like on a bunch of flowers. And the hole's gone.'

'Are you planning to repair potato sacks?'

'No, I've made a hole in my trousers. I'm going to mend it with a claisp. They're strong.'

'You've given me a metaphysical problem with your claisp.'

'I don't really understand. But don't worry about it if you can't find any wire.'

'Where do you normally put wire?'

'There was some in the kitchen drawer with the corkscrews and the tools. At least, there used to be . . .'

'There's not much left, if any.'

'I don't need much.'

I go and fetch some wire from the kitchen drawer and come back.

'Here. That's all there is.'

'That'll be enough. Thank you.'

'Do you think I'm teasing you with my metaphysics?'

'You say what you like. I listen to you but . . . Some of it goes in, some of it doesn't . . . To tell you the truth, I'm not sure what metal physics is . . .'

He goes off to make his claisp and mend the tap.

*

The next day he arrives like a whirlwind and brings his scooter right up to the door of the studio. He takes off his helmet and puts it in the crate fitted to the front.

*

'Yesterday I had to take off. Thinking about thinking did for my head. And with my helmet on top . . .'

'If you think you're thinking, you fall asleep. But if you dream you're dreaming, you wake up.'

'I just think about what movements I'm making. Otherwise I lose the thread of what I'm doing.'

'Our memories tell us how to move.'

'If you say so . . . My head's a bit mixed up, except

when I'm thinking about doing my garden. Then it's as if it's real. Just thinking about it, I can see my garden . . .'

'Some people make gardens with words. They sow and reap ideas. Or else they harvest new ideas made of ordinary words.'

'I've never thought about that . . .'

'If it weren't for words we'd be making signs and grimaces at each other. Or twittering like birds.'

'No, we'd be like babies, crying for our soup.'

'The main thing is to be understood . . . And then there's the context . . .'

'How do you mean?'

'The situation you're in. If you see someone in the sea who's drowning, and he shouts out, you imagine that he's calling for help. You haven't understood the words he's calling, but thanks to the context . . . And sometimes you understand the meaning of a word without knowing it, like when you're in a foreign country.'

'My context, as you call it, is the garden.'

'If you say "That's a load of manure" I know that because it's you, you are talking about real manure. But if someone else says the same thing to me in my studio,

I think that they don't like my painting. The words are the same, but the context has changed . . .'

'Thank you, professor. And what about the word "soup"? What does that mean to you?'

In September he insisted on coming to my home in Paris to 'do my garden' and 'give me a hand'. I went to pick him up from the station in the car. All dressed up in his best blue overall, with his clown's suitcase for his tools and his belongings, he suddenly looks delighted and relieved when he sees me at the end of the platform. He gives a laugh, showing his teeth – 'the bought ones'.

*

'Did you have a good trip?'

'Yes, thank you.'

'Is this the first time you've been to Paris?'

'No, I've been here before. Once in 1940. We were coming from the north and crossed Paris at night. I didn't see anything. There was a blackout because of the planes. Another time I came to see my eldest daughter.'

'You're looking well.'

'I'm fine. Being retired isn't tiring.'

'Have you got gold bars in your suitcase?'

'An anvil.'

'An *anvil?*'

'To hammer the scythe on. I'm going to teach you how to hammer a scythe. No one knows how to do it any more. With machines now no one needs a scythe.'

'It's heavy.'

'Of course it is.'

'. . .'

'What would you expect? I've come to see your garden, and also the daughter who lives in Paris. The son-in-law's found another job. He's a security guard at the prefecture, or the town hall or somewhere. It's a good job. They don't have to work hard. Anyway, it's up to them . . .'

'The car's over there.'

'You brought the car? In all this confusion? . . . Is there a fair on today? There are so many people . . .'

'It's like this every day.'

'Is that the Eiffel Tower over there?'

'No, that's the Montparnasse Tower.'

'Is that the town hall?'

'No, that's the Gare de Lyon.'

'And that?'

'The Arc de Triomphe.'

'The monuments are beautiful. Very impressive. But I couldn't live here. There are too many people. I've seen it on the television, but it's different when you see it for real. It's as if everyone's gone mad. Although when you're young it doesn't do any harm to get about a bit. And it's beautiful, really.'

'If you had it all to do again, would you come and live in the city?'

'I might do. But you need an education.' *Then, suddenly changing the subject*: 'Now tell me, have you got a scythe?'

'Ehm, I'll have a look, and if not, we can buy one.'

'Well, anyway, at least we've got an anvil.'

*

At the ironmonger's they sell different types of scythe – for grass or for undergrowth, with metal handles or wooden ones. He wanted to try one out in the shop: he tested its balance, its weight, its feel in the hand, its swing. As he scythed, he made circles and little whistling noises: 'Shlaff, shlaff' . . . People gathered round and watched him scything the air.

Back in my garden, he set to work, but declared that the scythe wouldn't cut anything and that he would have to

hammer it, sharpen it, whet it, give it an edge. He gave a demonstration. I was the disciple and he was the master. Each of us was sitting on a stone. The scythe rested on the little anvil. With a heavy, square-headed hammer he struck the metal with regular blows until it became thinner. Then I had to take my turn at beating. I learned how, with a bit of filing, you can give the scythe an edge.

I also learned to listen for the shlaff, shlaff *noise, slicing and whistling, the* zzeh *and the* sseh *sounds, neither too loud nor too soft. I got a feel for the movements to make so that your arm and your hip don't get too tired. I understood that reaping is like a dance, but something about the figure I cut made him laugh: I wasn't a real reaper yet.*

But I was happy. Using the scythe, I was reminded of the sound of the wind in the spokes of a bicycle wheel, the whisper of the tyres on the asphalt, and the silence of a well-earned descent after a long climb.

*

'You need to hold the scythe like this, not like that. That will make it veer off to the outside and you'll hurt yourself. You hear that sound? You scythe using your ears. Don't cut too much at a time – it's better if you take less

on each cut, but make it regular . . . You should practise a little every day.'

'It's good when you get into the right rhythm. You feel that it's doing it all by itself, without any effort. Like playing the cello . . .'

'Old men used to be able to keep it up all day without getting tired.'

'One of my hips is hurting.'

'That's because you're holding your instrument the wrong way. And you don't know the music yet.'

'A-*ha*! A-*ha*! A-*ha*!'

'That's better already. Now you're getting the hang of it.'

<p style="text-align:center">*</p>

We had just moved into an old house in the Paris suburbs and we were having plumbing work done by a moonlighting plumber who mainly came round at night. Our gardener would rise with the sun, go to bed with the sun, drop his 'falsers' in a glass and put on a stiff, well-ironed pair of striped pyjamas, his pyjamas 'for visiting'. But around midnight when he heard Raph, the plumber, he'd get up again and come and join us. He would straddle a chair (having checked that his

*pyjamas were 'decent') and listen to Raph telling us about
his latest invention, a sort of adjustable wrench. He'd listen
a little distantly; he had never heard a plumber talk so
eloquently before.*

*When Raph went, he would ask what this 'wrench' thing
was. And he'd say 'Your building site out there looks like
Verdun!'*

*He would marvel at this chap who came by night, a man we
gave money to, who told stories and didn't seem to do anything.*

*

'You should take me to see the sights to get us out and
about.'

'How about the Gare du Nord?'

'Whatever you like. The Eiffel Tower, the Arc de
Triomphe, the Seine, the streets, whatever you like.'

'Women?'

'I'd be happy to look.'

'Tarts?'

He laughs.

'Not for me.'

'Don't they do special prices for railwaymen?'

'No, they don't, but I'd be happy to look. Though it

might make me feel bad to see that. It smacks too much of poverty. I was always afraid of that with my girls . . . But they got married and had children, and their husbands don't drink. So we can't complain.'

'There are worse off than us.'

'As long as I have my soup and my herring.'

'And me my lamb chops and mashed potato.'

'A bit of variety for the spice of life.'

'A nice lettuce.'

'I'm not so keen on them.'

'And yet . . .'

'I know, I grow them. But I don't eat them. I find them tough. It's like eating old newspaper . . . I give my lettuces away and people are happy. Giving pleasure to others gives me pleasure . . .'

'Then what are you complaining about?'

'Nothing.'

*

'It's not bad, you know. It looks like a big gate.'

'Do you want to go up it?'

'I can see it fine from down here.'

'Up there it'd make you feel dizzy.'

'But from down here it's not bad. Perhaps you could drive round the square again. Can't you stop here? I'd like to see the flame.'

'It's under there . . . but you're not allowed to stop.'

'I know . . . I saw it on the television.'

'It's a gas flame.'

'Apparently it never goes out . . . Mind you, with the draught, it's for the best.'

'Do you like it? Shall we go round again?'

'I'm not tired of it yet.'

'All the same, it's just a breeze, a gas flame, a pile of stones, pictures in sculpture . . .'

'Yes, but it's good. It tells stories . . . and if it weren't for those stories . . . about the war, our country, there'd be fewer visitors . . .'

'OK, around we go once more for the sake of good stories about the motherland.'

'I'm glad I've seen it.'

'*The Song of Departure, Singing in Victory*. Naked blokes in helmets and swords.'

'They look like they've had a few.'

*

'And now for the Eiffel Tower.'

'It's beautiful, you know. When you're at the bottom, it's not the same as on postcards and in photos. You could get dizzy just looking up at it . . .'

'Do you want to go up?'

'Oh no, but if you can go around again or stop, I can tell my friends and the wife . . .'

'What will you tell them?'

'I'll say: "I've seen the Eiffel Tower," and I'll do this with my head and look up, so they know how high it is . . .'

*

The next morning I took him to the Museum of Modern Art. I explained everything to him. He looked, and didn't say a word. In the afternoon, we went to see the hothouses at the botanic gardens.

*

'Oh my, I've never seen anything like this before. It isn't half hot in here.'

'That's because it's the hothouse.'

'I'll have to take my jacket off. It's like an oven.'

'Do you like it?'

'Heavens, I've never seen anything like these plants.'

'It's some garden.'

'I'd never have imagined . . .'

'But your lettuces, though . . .'

He laughs.

'My lettuces are nothing compared to this.'

'All the same, a nice lettuce . . .'

'When you go to the Museum of Modern Art, doesn't it have an effect on you?'

'I'm completely gobsmacked.'

'Well, it's just the same for me here.'

He went home full of tales. At Christmas, he sent a card: 'Happy
New Year! Good health to all the family and see you soon for the
holidays.'

*

The holidays arrived. He came to see me straight away. The
usual greetings, long explanations, and a tour of the garden,
where the lettuces are bolting, the courgettes going wild, the leeks
drying out, the beans climbing. He's taking good care of the
garden, his scooter's working, the kipper bones criss-cross on the
ground under the pear tree where he's been eating his snack.
Tomorrow morning we'll begin our conversations again, our
'sparring' as he calls it. 'I've missed it. Really I have.
Something's been lacking.' Tomorrow, I promise. 'Let battle
commence!' he says. 'See you tomorrow.'

*

'You still drawing your field?'

'In a way.'

'I'm beginning to get the hang of it from watching
you.'

'In the end it's not difficult, you know.'

82

'It doesn't look it, but I can't imagine doing it.'

'You always say that, but you're desperate to have a go.'

'Oh, no.' *He laughs.* 'I can't see me doing it. First of all, I don't know what you're aiming at. When I'm digging a plot in the garden, I know where I'm going. But with that . . .'

'I don't know where I'm going, either.'

'No, I couldn't do it . . . It's a funny job . . . I look at what you're doing and I think I understand it, but to get there, you need to spend time watching you do it.'

'What if you had one of my paintings at home?'

'Well . . . maybe . . .'

'We could exchange our work: some lettuces and leeks for a picture. A swap.'

'Well . . . I mean . . . it's not the price that would embarrass me, although I don't know what they're worth. I've no idea what they cost.'

'I didn't make myself clear: I'll *give* you a painting and, if you want to, you give me some vegetables. Let's say a crateful of vegetables . . . or more, if you like.'

'You're having me on! I know for sure that your pictures are worth more than a crate of vegetables.'

'You see, you *do* have an idea of what they're worth.'

'No, but I've got an inkling . . . as I said . . . I like them. I understand them a bit, but the wife's never seen them – she wouldn't understand. And it wouldn't go with what we have at home . . . the horse painted on velvet, the framed view of Lourdes, the portraits of the children. It would stick out. And we haven't got much space . . . No, I think it'd be better if you hung on to it. No one at home would appreciate your picture, and that'd be a pity. I'm the only one it'd remind of happy times. My friends, the family, the son-in-law from Brive – they'd all make fun of me. They'd take the piss and call me Picasso. And what would I say to them? Can you see me explaining your field to them? What would I be like? It's not my kind of thing. Each to his own. And even the children would be the same – they wouldn't understand. And it would sit in a corner and get damaged. Knocked around . . . It's best if I say no . . . But thank you . . . Maybe some other time . . .'

*

'The son-in-law and the daughter have had an accident in the caravan in Cahors. This bloke cut them up . . .'

'The Akileïne son-in-law?'

'Yes, the one with the camper van.'

'Are they hurt?'

'No. It turned everything upside down in the van, but it didn't do any damage. In the "carriage", as they call it, everything's attached with those elastic thingies, so nothing can move around unless you brake a bit sharpish. They broke a picture frame and a shaving mirror. But the chap who cut them up crashed into the post office.'

'Was he hurt?'

'A bit concussed, apparently. He admitted he was in the wrong. The police were on our lad's side . . . They know him.'

'So it wasn't too serious after all?'

'They cut short their holiday. The caravan had a puncture and one of the headlights took a bit of a knock. The son-in-law would have repaired them himself but he didn't have his tools in Cahors, and he was worried that he'd buckled the front axle so they came home. The daughter cried. It's true, you go on holiday and the day that you come back . . . She'd prepared everything. There was even a bunch of flowers on the table attached with one of those bungee things. It didn't move. Nothing. Only

the water in the vase got jolted. It's pretty, their Akileïne caravan.'

'You know, that Akileïne stuff's good. It stops you stinking.'

'Ah yes, that . . .'

He laughs.

'It makes you laugh.'

'Yes, at least we've got that left, us poor old souls, having a laugh. Anyway, everywhere smells of lemon nowadays . . .'

'But you have to admit that feet . . .'

'Don't smell too nice.' *He laughs again.* 'Some of the ones you come across on military service would make you wonder how we could lose the war.'

'Feet stink, especially in wartime.'

'Not just feet.'

'Mind you, a bit of natural odour is good. Women smell a bit, and men too. You have to have a smell to awaken the animal within.'

*

'Did nothing happen in Nice this year?'

'The wife got sunstroke.'

'Had she stripped off?'

'A neighbour lent her a bathing costume and she lay and baked herself on the sand. I kept my leather waistcoat and trousers on. The sun roasts my skin and then I can't sleep.'

'So she got sunstroke?'

'She's not used to it. Living cooped up on our estate makes her look like she was born up north in Tourcoing or somewhere . . . She lay there three days without moving and by the third day she looked like a photographic negative.'

'Has her skin peeled?'

'No, but it made her look like she was off the films. We agreed she'd better stop. On the estate we'd be a laughing stock. We spent the last few days in our room. She started to turn white again with the shutters closed. There was just a little bit left, but the neighbours didn't say anything. Only one woman said "What happened to your wife?" and I said that it was the fashion to have a bit of colour.'

*

'I didn't tell you yesterday what happened to me last year in Nice. One day I needed to take a leak, and I said

to myself, "You can't pee in the sea like the rest of them . . . You have to go somewhere else." So I went against a retaining wall on the railway. I thought to myself, "It belongs to the SNCF, so it's almost like it belongs to me, too . . ." Well, the Old Bill saw me and fined me. It cost me 3,000 francs.'

'In the new money?'[1]

'No, old. Thirty francs for pissing against a wall! I was upset. I wanted to leave right away. The chap in the hotel told me that if it'd been a parking fine he could have got it dropped, but as it was a peeing fine he couldn't do much . . . What do you make of that? Don't you think they're mad?'

'Thirty francs for peeing against a wall . . .'

'And don't you think people who let their dogs shit everywhere are worse? Every ten yards along the wall there were yellow turds that looked like cigars. And I saw the dogs that did them. Fancy breeds that would come and do it on your feet. Their owners pretend not to notice. Nobody says a dicky bird to them . . .'

1 De Gaulle devalued the French franc one hundredfold in 1959, but many older people still talk in the 'old money'.

'So dogs are shit!'

'Yes, they certainly are. I went to talk to some men working on the railway about it. But they weren't French and they didn't understand what I was on about and their foreman sent me packing. I spoke to him but he wasn't a very cheery sort, and he didn't understand what I was doing, following them down the track . . . I went back to the hotel and slept. We went out that night, but we couldn't relax . . . Evening's the time for mosquitoes, mind you. My face was all swollen on one side. I thought I had a gumboil coming. They're funny creatures. You'd think they were trained to go for the tourists. The way they make you look! It doesn't make you keen to hang around. Or go back.'

'So did you leave?'

'We'd paid up to 26 August so we stayed till then. We went on a boat trip to the islands for the last few days, just for a change. We did the full tour. I didn't get seasick. The wife did, but it doesn't last. Apparently some people saw a shark, but I couldn't see anything where they were pointing. Seemingly they do get sharks there sometimes.'

'But fish you do know about, though . . .'

'Yes, I do, but you have to be properly equipped. I didn't have anything with me. But you're getting me rabbiting on again and I'm expected for my soup.'

*

'I didn't tell you yesterday . . . I forgot again . . . Our trip to Nice is coming back to me in bits and pieces. I need to sort it all out in my head . . .'

'. . .'

'Well, we went to see the Sentier boy – he works in a big restaurant. His father told me to go and say hello to him. So we did. Do you know who I mean?'

'. . .'

'The Sentier boy. Our downstairs neighbour on the estate.'

'Yes, I think I'm beginning to understand.'

'He's got a good job. He's maître d'. He dresses in black with a clean white towel folded over his arm. He couldn't stop fiddling with it. After a minute his boss called him and he had to get back to work. He's polite and well brought up. It's his job. It's the right one for him. He gave us ten thousand francs – a hundred francs in the new money – to have a drink with his

father. The old man was pleased when we gave it to him . . .'

'And you're telling me all this because . . .?'

'You know. Just to make conversation. It comes back to me a bit at a time. Our trip when nothing happened. You think that nothing happened, and then you remember little things. Mind you, if you remembered everything . . . The more you get me talking about this trip, the more it comes back to me. I see myself with the wife, not thinking about anything in particular, watching out for the traffic, looking to see if anyone is looking at us, looking at the sea, which is hard to see, a seagull, a palm tree. It seems to me that the shadows are blue and the light's yellow. It stayed like spots in front of my eyes. What does it mean if I can see that now and I couldn't see it when I was there? Well, I doubtless saw it, but now it's clearer and I realize that I saw it. It's like in the Museum of Modern Art when you showed me those stripes like on a building site. I thought they were a joke, but they made me think. I don't look at a locomotive the same now. I look at it in its own right, not just as an engine that pulls carriages.'

'I thought you didn't like that museum.'

91

'It's not that I didn't like it. It's the same when I go mushrooming: I look for what I want and leave the rest. Here, you're making me ramble on. I'm going to water my leeks or else they'll grow pompons on top . . .'

*

'I'll never get to the end of telling you about it! Our holiday in Nice, I mean . . . I was lying in bed one morning, not sleeping, just looking at the ceiling. The wife was asleep. It was sunny outside . . . I could hear noises from the street. Near the hotel there's a garage and I could hear the sound of tools striking metal. You can tell from the noise when they're changing a wheel. So I wasn't sleeping, I was looking up at the ceiling. The shutters were closed, there was just this crack of light getting through. And up on the ceiling was the exact image of what was going on in the street. I could see it just like on television. Movements, people, everything . . . I woke up the wife, who moaned and said she couldn't care less, so I was the only one who saw it. It was seven o'clock in the morning. I didn't tell anyone about it . . . Television on the ceiling!'

'It's the Renaissance painters' *camera obscura*.'

'The what?'

'It means the "dark room". Artists would use a simple hole in a box to project the reversed image of what you could see outside . . . The camera was constructed on the same principle when they found a way to fix the image in light.'

'You have to be clever to understand things like that. You can't live like a peasant any more, only knowing about plants and clouds and the sun. Even stupid people need machines. When I see children today and what they have to learn . . .'

'Did you go to the museum in Nice?'

'No, I didn't realize . . . We went to Monaco on the bus like we do every year to see the oceanography museum. You can see sharks in a tank up at eye level. Fish and eels and seals and whatnot. The wife was afraid: "What if the glass in the tank breaks?" she said. We also visited the Royal Gardens and the prince's kitchen garden. They call it a vegetable garden, but I don't know where he hides his cabbages and green beans. I asked but they didn't understand. But it's beautiful all the same, with all those exotic flowers, those big cockades with frills

Henri Cueco

everywhere. Keeping it all tidy must be a fair bit of work.
I talked to the gardeners, but they weren't very chatty.'

'Did you see the Princess?'

'We did see someone who apparently was the
Princess. The wife recognized her. She waved to us.
Perhaps it was her . . . I asked the gardener and he
laughed and said: "Princess? They're all princesses
here, Your Highness!" The bugger was pulling our
leg. But that doesn't matter. We told them on the
estate that we saw the Princess in Monaco. Some of
them were jealous. They're wrong to be – it doesn't
mean anything seeing a princess in her garden.
Anyway, what can you say . . .? Princesses are just like
the rest of us.'

'Not necessarily, if she's a real princess.'

'I'm going to see what mine is up to.'

'Is it time?'

'It's the time when she awaits her prince.'

'Ah!'

He laughs.

'Her prince who arrives on his motorized steed.'

'Hah!'

'She'll be making you salade niçoise, ratatouille, and pissaladière.'

'I'm not that keen on those. They give me such a thirst. And I've had my fill of ratatouille. Every day in Nice, more or less. They have it with everything down there. Tomatoes and courgettes grow in flower pots. But when you have to work hard in the sun, in ninety-odd degrees, they're not that nourishing. We need a bit of rain here, then I won't have to do the watering.'

*

From the house, halfway down the hill, I can hear his scooter's engine in the distance. It putters in the open country, goes quieter when a hedge muffles the sound, and then putters again even louder than before.

Between the fields, going down towards the Maison Neuve, to the Mas du Puy, you can see the blue-grey strip of local road no. 36. It's well maintained, with a good surface which is regularly patched up by the road menders with gravel. It looks smooth from afar and resembles nougat close up. Its rough texture grips the tyres of his scooter firmly, and the sound travels, rising and falling, as he passes the trees.

And there he is, wearing his helmet high on his head like a

Mayan priest in majesty, his eyes slanting beneath the visor. He's dressed in the bright blue of the SNCF and the grey rabbit-fur gloves that he wears summer and winter, steady in his big rubber-soled boots, with his feet balanced asymmetrically on the pedals, one in front, one behind.

*

'How are you?' he says, taking off his helmet and bringing his new scooter over the threshold. Given half a chance he would have brought it right into the dining room. He takes a step back and looks at the scooter, and then at me looking at it. He smiles, makes an admiring gesture and shrugs a little self-deprecatingly. Then he wheels it back out, sets it on its stand and straddles it again, with his hands on the handlebars and feet on the ground. On the back there is already a crate for vegetables, attached with a bungee strap, containing a sack of potatoes. He turns the scooter around on the terrace and puts it back on its stand, so that it's visible from the kitchen and the living room.

*

'It's beautiful.'

 I crouch down so that it's at eye level.

 'It's brand new. I got it yesterday.'

 'It could be new and *not* be beautiful.'

96

'But it is.'

'Yes, it is. It certainly is.'

'It's a good one. A Terrot.'

'As in "terrain".'

'Yes, but not spelled the same way.'

'Will you keep it in your flat on the estate?'

'It's not easy on the stairs. I'll put it in the cellar. I've got a cellar I can lock up. That's where I do my DIY.'

'What if there were a lift?'

'I'd put it in the hall, but the wife wouldn't like that. It smells of petrol, and she doesn't like that. She insists on me washing my hands after I've been repairing my scooter.'

'It must go like the wind.'

'It's pretty nippy . . . Maybe even a bit *too* quick.'

'Did it come with the carrier?'

'Well, I've made a few improvements . . .'

'It's a beautiful machine.'

'It's a 125. It goes well and it's well made . . . The dealer who sold me it gave me five per cent off the price.'

'Did he take your old one in part exchange?'

'He said he didn't want it even for scrap.'

'That must have been upsetting for your old machine.'

'I'm keeping it in the cellar. It might come in handy one day.'

'That one is elegant.'

'Yes, it isn't bad . . . Beautiful . . .'

'Like a woman.'

'I don't know about that . . . It's just my transport, to get me around . . .'

'Women can transport you, too . . .'

'You're right . . . Mine dreams all the time of travelling. She wants to go to Algeria and look for her family.'

'You can go on your scooter.'

'I'd need a trailer and flippers for the crossing.'

'Anyway, it's beautiful. Well made. A decent piece of French manufacturing, strong and serious.'

'It might well see me out. It's brand new and I'm starting to rust all over.'

'You're still going strong. If you like, we can do a swap . . . I'll give you my old body and you give me yours.'

'You wouldn't gain much there. My rheumatism, my guts, a head that's not worth much, and I'll spare you the

detail . . . I'm the only one who could get any use out of it.'

'And I'm like one of those old bangers that have been patched up and go from one garage to the next.'

'I'm like a hay cart. The axle creaks and the horses don't go fast. When I think what I was like even two years ago . . .'

'It'll come back.'

'Hah! It may come back, but much good it'll do me. They say that you suffer less in heaven . . . Oh well, as long as I have my tool shed and a bit of land . . .'

*

'You won't see me for a fortnight. I'm off on a trip.'

'What, another one?'

'I said to myself, "If you've got a bit of money the year you retire, you should see a bit of the world before you die."'

'And you've got the money?'

'Oh, we get by, what with the union, my senior citizen's card, and my reductions on the railway. And then with savings and new clothes that you only need to buy once. And the daughter, the one in Paris, works in a travel

99

agency and she gets special offers. She helps fix us up with cheap tours.'

'So where are you off to now?'

'Algeria. The wife really wants to go . . . She wants to find her family.'

'And what are *you* going to do down there? They'll take you for a colonial, you know . . .'

'Oh, we'll see what they take me for. They won't eat me. I'm not the one who wants to go, it's the wife. She's from down there, you see – she's Arab by birth. We don't mention it on the estate. It's not obvious unless you know. A big beanpole like her, with her fair hair, and thin – who'd take her for a darkie? She doesn't have an accent. She hardly knows how to make couscous.'

'But she can do it?'

'She saw a recipe in the newspaper and gave it a go. It was nice. A bit filling, but good. Especially the vegetables – the carrots and chickpeas.'

'So when are you off?'

'We're leaving for Paris tomorrow to catch the plane. The wife's going to look for her family in the desert.'

'Watch out for the old noddle! You'll need something

to cover it up, and some sunglasses, something to strangle the lions with, and to slit the crocodiles' throats . . .'

'I've got my string and my knife.'

*

I could picture him in the desert in his ironed overalls and the wraparound dark glasses he uses when he's breaking stones, his eyes covered by the big round lenses, like slices of black pudding.

'So how was the Algerian trip?'

'Good, but it was too hot. The wife found the house where she was born. Her sister had died and she doesn't have anyone left there any more. At least, she didn't find anyone. No sisters or brothers. All dead or gone . . .'

'Did you pick up some Arabic?'

'No, I didn't. They speak French just like we do . . . We walked around, saw the palm trees and the camels. I've never seen so many.'

'Did you see the desert?'

'We went to the edge and had a look. It's nothing but sand. We stayed for a bit. The wife picked up some sand in her hand. I did the same. It's warm as it trickles through your fingers. You can't hold on to it . . . We didn't stay long but my shoes were full of it and – you won't believe this – I'm still finding it in them, and in my pockets. Even yesterday, and we've been back ten days.'

'What were the people like?'

'Just like anywhere else. They walk around, go to work, or not, just like anywhere. They're polite. There

was one chap who wanted to polish my shoes. I couldn't get rid of him. The wife had to give him an earful in Arabic. I suppose she told him to get lost, but she didn't tell me what she said. He wanted to polish my old clod-hoppers!'

'Do the women wear the veil?'

'Some do. A white one. Sometimes all you can see is their eyes.'

'Did you eat well?'

'It's all a bit samey, but I liked it well enough. I'm not fussy. As long as it's hot and hasn't gone rotten. You know, even if it's starting to go a bit off, it doesn't do any harm. In the past I've eaten things that a dog would turn its nose up at. In the old days there weren't any fridges. We ate what we could get. For my taste, the Algerians put too much chilli in – it sets your whole bloody mouth on fire! You can't tell if it's good or not because everything tastes the same. It burns your throat. You can't feel anything. And the more you try to put out the fire with water or wine, the more it burns. That makes them laugh. Even – what do you call it? – Montezuma's revenge, the runs, makes them laugh. We had it for three days. I thought

there wouldn't be enough desert or sand dunes to hide myself in.'

'How was the journey?'

'We flew.'

'Did you like that?'

'I liked it, but I was a bit scared. You don't really realize, but when the weather's clear you can see the sea down below. Well, you see the sea because you know it's there, but although I had a good look I couldn't make out that much. And the clouds from up there look like someone has planed them flat, they're smoother than from down here . . . They kept giving us things to eat all through the flight. I couldn't take it any more in the end. It was nice, but it was odd – little bits and pieces piled up in plastic boxes. I couldn't recognize any of it. It was hot. We had two meals like that, all included in the price of the ticket. At one point the plane went *voom*! and dropped and I didn't have time to catch my glass. It was an air pocket, apparently. I thought the plane was heading for the ground.'

He makes a downward motion with his arm towards the ground.

'So you saw palm trees and camels and that's it?'

'There were certainly other things to see, but the sun heats everything up and dazzles you. It's blinding. It's as if everything's shimmering in front of your eyes, like when petrol evaporates. You don't necessarily see things better there. When you go into the shade everything goes dark. I can't get used to the sun. It's worse than in Nice down there.'

'What about your sunglasses?'

'I took the goggles that I wear when I'm breaking stones. They protect you on all sides, but you can't see that well.'

'You could have bought some.'

'We weren't there long enough. Barely a week and we spent our time looking for the wife's sister's grave. In the end, the wife was happy – it brought memories of her family and her house back to her. She cried at the grave, but she wasn't sure that it was the right one.'

'It's hard when the whole family has disappeared.'

'That's what she was expecting, but it made her sad not to find anything. I can't say – I never met them. We sent them cards when their children were born, but they

didn't reply . . . From our side you couldn't say we got in their way.'

'So it was a sad journey in a way.'

'No, it was good. It let us see a bit of the world – the plane, the hotel, the people, the palm trees, the sand, the sea. It looks like it does on television, yet it's different. On the TV, you can't feel the wind or smell the smells. It goes by too quickly. I like to look at people, take my time. I'm not doing anyone any harm, watching people go by, thinking about the fact that we're all the same. Like ants or rats. At any rate, I feel better when I know I'm like other people – no more or less of a rat than them.'

'Like moles . . .'

'Don't talk to me about those damned things. I thought about them in the desert. The dunes looked like a field dug up by giant moles. But it made me think that I've got to bump off your moles. Meanwhile, it's time for soup!'

*

He comes in without knocking, hitches his trousers up, and positions himself right in the middle of the studio. He says nothing

for a long time. Like a knitter counting stitches, I become deaf.

'The pumpkins . . .' he says too loudly, and then lowers his voice. He realizes that he is disturbing me, but what he has to say is too important to let pass.

*

'Have you seen the pumpkins? Have you seen the one that's against the fence? It's almost ripe.'

'. . .'

'It's almost there. Nearly ready to eat. Will you tell the wife?'

'. . .'

'I'm going to have my soup. Will you go and take a look at your pumpkin? They'll soon spoil in this weather. In ten days they'll be all gluey, like jam.'

'I'll go right after lunch. I think pumpkins are beautiful. I love seeing their big buttocks.'

'Well, you've got one that's a fine specimen.'

'Fine, and beautiful. Last year we had seven in the courtyard. They were superb. Yellow and red, orange, and inside you would think . . . that they're alive.'

'It's a beauty, you'll see . . . Right, I'm off. Time for soup! Maybe there'll be pumpkin in the soup . . .'

'Pumpkin soup is nice.'

'They say it's not bad. But to me, the pleasure of a pumpkin is seeing it grow . . .'

<p style="text-align:center">*</p>

We're by the rose bushes, which he's pruning. He's also turning over the soil around the base of each one. Suddenly a low-flying plane roars overhead, and it feels as though the sky's falling in.

<p style="text-align:center">*</p>

'My, that was close!'

'You'd think we were at war.'

'They don't have the right to do that.'

'They do it all the same.'

'Yes, but they've got no right. It makes eggs hatch and chicks die. Quails' eggs and pheasants' and so on break open before they're ready. I read in the paper that a sonic bang made a castle tower in the Dordogne collapse.'

'It couldn't have been a very sturdy castle.'

'It was being repaired. A sonic bang must be powerful to make a tower fall down.'

'It's called a sonic "boom".'

'Boom, if you like . . . When they let off, they do damage. Those booms happen a lot. The other evening I

thought it was thunder . . . It made me take cover. And you hardly have time to be surprised before it's over.'

'They go a bit quicker than your scooter.'

'My scooter doesn't make a sonic boom. But it back-fires from time to time. When the gases build up and go off suddenly, it makes a sort of *phut*. People turn round. I act as if nothing's happened, but they suspect that it must be me. The other day, I thought the level-crossing keeper's dog was going to knock me to the ground – you know, the little sandy, white one with a face like a lizard. He was barking and chasing the scooter, and managed to get himself in front of it. I thought I'd never get rid of him. And then there was one of those boom things. He stopped and went all cowed . . . Those little dogs in the countryside are bloody awful. You'd think they'd been specially trained to be stupid. The owner might be polite, say good morning to you, but, you know, he's no better than his dog . . . I'll finish your garden this afternoon. I've had enough for this morning – that plane's taken the wind out of my sails. And anyway, it's soup time.'

'I'm disturbing you. I can see I am. But I have to tell you . . . I'm not happy that I have to and I know it's a nuisance, but she's someone I've talked about to you, and at home they said I should tell you . . .'

'Is it so difficult?'

'. . .You've got to visit a woman who's died.'

'Yes?'

'You were at school with the son. Your parents knew her well. The old woman's died.'

'At the little house down near the bridge?'

'Yes, the mother of . . . I can't remember his name, the one who worked on the railways like me. It's his mother who's died. We have to go. I'm coming too. At home they agreed that you should come with me.'

'I'll get changed and we'll go.'

'I'm going as I am.'

*

He goes ahead of me and enters first. He knows what to do. He holds his cap in his hands and turns it like a steering wheel. I make a similar gesture without a cap. He greets them stiffly, as

110

though he's fallen out with them. There are three of them, but they are hard to make out in the gloom: the two sons and a woman in an overall who's sniffing. The two sons seem to be looking at their feet as if they're ashamed. They're standing up. No one knows what to say. Someone whispers 'My condolences' and all the others reply 'condolences'. For some reason, the sound of the word makes me think of a gondola and a packet of those 'gondolo' biscuits.

Then they all fix on a point and we look. In the dark, a few feet away, on a child's bed made up with stiff white sheets, lies the old lady, all dressed up, her hands crossed, a little twisted, it is true. She's the colour of mastic. She is tiny . . . almost like a statuette, turning yellow minute by minute, becoming lemon . . . her lips are pursed as though she's about to give her sons an earful. She is so still that it seems as though with each little beat of my heart I can see her move. How long do we have to stay? We look at the floor of the next room, which is bathed in light, and the flagstones in the kitchen.

*

'She didn't suffer,' *says the woman*. 'She went out like a light. She'd come to the end of the page.'

'The poor thing,' *says the first son*.

111

'Yes,' *agrees the second*. 'She hadn't been getting out much lately . . .'

'No, not much,' *says the older one*.

'Not any more. Just to get her bread.'

'Her bread,' *echoes the sister*.

'She died suddenly. Pouf!'

'It was her heart that gave out.'

'She was worn out . . . She'd seen a thing or two. Oh, the things she'd seen!'

'You can say that again.'

They say all this very quickly, as if it were a recited text.

'In the old days, life in the country wasn't always easy.'

'The old folks have seen a thing or two.'

'Today it's easier, what with doctors, and television.'

'She loved her television.'

'Especially the weather. She liked to know what the weather was going to be.'

'She used to tell us what it was going to be the next day. She thought she was the only one who knew.'

'Oh, it happened so quickly! When I think that only last Sunday . . . She was taken from us quickly, she really was.'

*

Silence. And sighs. The brothers offer us a glass of wine, which we refuse. We shake hands, the sister sniffs. When we go outside we are dazzled by the light; the green of the trees seems too bright, they stand out like on a colour postcard. We go out, turn around. The three of them are at the door. Even from out here we can hear the sister sniffing.

*

'The funeral's tomorrow, but I'm not going. I don't like burials. I can't see the point.'

'And the point of death is?'

'It clears space for the young. You see all these old people cluttering the place up. Getting old is no joke. What are you going to do with all the old folk? As long as I can work . . . That old woman down there kept going right to the end. I used to see her sometimes. She was nice, but she'd lost her marbles, poor dear. With those two hulking great sons of hers in the house . . . She wished they'd get married, but could you see any life in them?'

'. . .'

'I'm going to pick some veg for you before I go for my soup. Death gives you an appetite.'

'What were you thinking about when we were there?'

'I don't know. Leeks, maybe.'

'You were turning your cap.'

'I didn't realize.'

'What did you make of her?'

'Dead, poor thing. As dried up as shelled beans. Completely dried up. There wasn't much of her left. They'll be able to fit her in a corner of her box. She's not going to be lifting the lid.'

*

'Do you need me?'

'I'd like you to help me realize an old dream . . . I'd like to have a loo in the open air.'

'Well, if that's all . . .'

'Just an upturned box with a hole in it. We'll put up an umbrella for wet days, and it'll be a parasol the rest of the time. A big umbrella like at the fair. We'll cut a nice hole in the box and polish it. The edge of the hole will be pleasure itself.'

'It's rubbing your buttocks on the edge of it that polishes it. The first ones to use it might get a bit scratched.'

'It will be a privilege for our guests. We've always got guests here, so it'll get polished quickly.'

'I'll put a heap of earth nearby so that you can cover it up each time . . . what with the flies. And the wasps. And even the hornets. Now, if a hornet stung you there . . .'

'The very thought . . .'

'We'll make it a masterpiece. You'll see – it'll be the best in the world. I know just the spot for it – down there under the oak where it's sheltered. It's a bit low-lying, and it'll be hidden by the acacias and hazelnut trees. When you look up, you'll be able to see a patch of sky.'

'Show me where . . . Ah yes, that's good.'

'You're better off out here than inside, with those flushes that are so loud you'd think the house is coming down around your ears. *And* they smell. Either of shit or of air freshener. Outside the smell gets lost in space. And at night you'll be able to see the stars.'

'My cosmic revolution will begin on the thunderbox!'

'Good. Well, I'll make your toilet for you. You can paint it and tie a little bell to a tree. When you've got company, you can give a warning that someone's coming by ringing the bell.'

'That'll be stylish. Not all that modern, but stylish.'

'It doesn't have to be modern. What you're planning to

115

do in it isn't all that modern – it's always the same thing. Some things don't progress. Is that the sort of reflection you'll make on your throne?'

'It won't be progress, but it'll certainly be an improvement.'

'Seemingly there are people who slash paintings with knives. I wonder what they think there is to kill in a painting . . .? Now that I know how much work they are, I can't see the pleasure that anyone could take in destroying one. It's like me taking my knife and murdering the best cabbage in my garden . . . Since I started watching you, I've been paying attention when they show paintings on the television. Before I wouldn't have bothered. But – how can I put it? – often what they show – mind you, you can't always see it very well – well, it's nothing special. Sometimes you wonder who it is who's mad, the one who painted it or the one who's looking at it. Not to mention the one who's explaining it. Those programmes make the kids yell like you were taking a steel comb to their hair. Sometimes there's so little to these works of art. I remember in Nice we went into a gallery – well, no, we didn't actually go in – we just looked through the window – and in the middle of the room there was this heap of earth and against the wall were some planks, a

panel that looked like it had just been repainted in a single colour.'

'In your opinion, what is a work of art?'

'I don't know. Other people have to agree about it. It wouldn't make sense if it was just my opinion. A work of art is like a star, like that painting that everyone knows. That Mona Lisa's a star.'

'Yes, but she's got it in the neck a few times.'

'Well, what does she expect with that look on her face? If you want to get yourself noticed, you might as well go for the Mona Lisa.'

'Didn't you want to chuck a stone at her?'

'There were too many people about, and anyway . . . What good would it have done? Mind you, I did think about it. Maybe not a stone, but I can imagine clobbering her hat with my spade.'

'She doesn't have a hat.'

'Her wig, then.'

'Do you think it's a wig?'

'I think she doesn't have any hair. Maybe she's a bloke. One of those . . . what do you call them?'

'Transvestites.'

'Men who dress as women.'

'Is that what annoys you?'

'It could be. But it's mainly that smile that gets bigger when you look at it. If she was alive, it could get her into trouble.'

'Lisou asked me what a philosopher is. I didn't know what to tell her. We don't have a dictionary at home and she was afraid the teacher was going to tell her off. The neighbours didn't know, either. According to Benoît – the chap who does nights at the factory – they're people who think and write about the things people do . . . So what does it mean?'

'It means "Lover of wisdom" in Greek.'

'. . .'

'They're men who have learned to talk about our concerns . . . About important questions of life and death.'

'Like priests, you mean?'

'Priests don't seek the truth. They believe that they've found it already. In fact, they're the opposite of philosophers. Priests know the answers. Philosophers don't, but they seek them. They ask themselves questions. Though the most difficult thing is to know which questions to ask and how to ask them.'

'Like about death? For example, what happens to us after death?'

'For priests and believers, after death we go on.

Philosophers don't know. They don't even know if the question should be asked. Or rather, they think that the question is itself a sort of answer.'

'You're going too fast for me, just like they do on the television.'

*

'Did you notice that I've broken one of the windows in the barn? It was the mower – the blades picked up a stone and flung it at the glass.'

'That'll bring good luck.'

'Well, it's good luck that starts off badly. I don't see what good luck could come from breaking a window. That's just rubbish, like horoscopes. Do you believe in reading cards, and fortune-tellers and crystal balls?'

'None of them. No one can predict the future. We don't even understand anything about the present . . .'

'And we can hardly even predict the past. People who do history never agree, even though it's about things that really happened. They can argue over dozens of different ways of telling the story of a single event. They write books about it. People who were there didn't see the same thing. Even with the TV, you don't really know

what happened, and even if you're there you don't see it clearly, or don't see everything, or see what you can or what you want to . . . Anyway, I don't see why I should have a star that looks after me . . . The broken window's not like a broken mirror. It's mirrors and looking-glasses that bring bad luck when you break them.'

'Why?'

'When someone dies you have to hide all the mirrors in the house – otherwise the dead person's reflection could still walk around in it as if he was alive. Dead people that stay dead are one thing, but the living dead are something else . . . In the country they don't like people who spend their time admiring themselves in the mirror. They used to say – I'm talking about when I was young now – that it wasn't healthy to look at yourself. "Don't spend so much time looking at yourself, you'll twist your face," my mother used to say. And if you made faces in front of the mirror, some people said your face would stick like that if you breathed on the mirror.'

'Why?'

'I don't know. Mirrors are to help you look nice, when you've stopped working. You don't need to look at your-

self to be able to work. In the country, you had to be rich to have a wardrobe with a mirror in it. It would go in your parents' room. When you looked at yourself in it, it was to be sure you looked your best, because you were going out to the fair or a funeral.'

'Do you have a wardrobe with a mirror at home?'

'Oh no, the children broke it. But I kept bits of it for shaving. When I set my mirror up – it's the shape of a cow's horn – I can see myself just as well as if it was square. It's just the same.'

'And your wife?'

'When she gets dressed up to go out, like when we're going to Nice, or to try on a dress, she goes to our neighbour's. They give each other a hand trying things on, with their hems and so on. I get to see the dress when it's finished. They don't ask my opinion, anyway. That's not my department. I don't know anything about dresses. But I think a new dress in nice colours instantly makes a woman look more beautiful . . . It's good to look nice on holiday.'

*

'It'd be better if we put the wheels in the air. You can turn the pedals and I'll adjust the derailleur. It's a fine bike

you've got here, you know – a bit complicated, but good all the same. Though eighteen gears aren't a whole lot of use. In my day derailleurs didn't exist. We got up hills fine without them. You just had to push with your legs . . .'

'I wanted a bike that would make it easy to get up hills. I saw lots of little old men on TV going full pelt up Mont Ventoux and they weren't getting tired . . . They looked happy just pedalling round and round in the void. The bike salesman told me that I'd be able to climb a vertical wall without suffering . . .'

'Hah, they say that to sell their bikes, but you're the one who has to do the pedalling. It's a good bike, but I can't work out how to adjust the gears at all. I didn't bring my glasses.'

'Try mine.'

'Heavens, I can see as well as when I was twenty! They suit me.'

'I'll leave them to you. They're worth as much as the bike – they cost 1800 francs, and the bike was 2000.'

'If I've got the choice of what I inherit, I'd rather have the bike. The specs suit me, but they're slipping a bit on my nose.'

'My head's too big.'

'I'll twist the arms.'

'Anyway, the inheritance can wait . . .'

'I've tightened the brakes for you and adjusted the derailleur. Normally it should work like that, but you're going to have to keep this lever pushed forward. I've blocked it here. It tightens the gears. They'll hold better. It wasn't tight enough before.'

'They slipped on the hill, and all of a sudden the chain went on to the big gearwheel at the front, and since I had made a bet with myself that I wouldn't put my foot down on the ground . . .'

'Here, take your specs. They suit me better than the ones I got from a neighbour. They're more or less all right, especially in this eye.'

'Before, when I had the knackered old bike, people would say: "Look at that old bloke on the crap bike!" Now, when young people see me on this marvel, they say: "Look at the nice bike that old wreck's hauling himself around on!"'

'There's no pleasing some people.'

'I don't want to disturb you. I just came to say that I won't be coming tomorrow. I'm going to the doctor's with the wife. Lisou needs to go, too.'

'Are you all ill?'

'No, but we're entitled to a free visit every year through the railway. A special van comes and the chap listens to your heart and looks at your X-ray. He also takes some blood and you pee in a tube. It doesn't hurt and you're all sorted . . .'

'You'd prefer to know if you're ill?'

'I'd prefer not to suffer. When it's time, it'll happen.'

'Some people die in good health.'

'So it seems. Old folk in my day died without getting ill.'

'My grandmother on my father's side died like that.'

'Yes, apparently that used to happen . . .'

'And when people were on their deathbeds they didn't always call the doctor. So they died in good health.'

'It's a funny idea, dying in good health. Not bad at all.

It's better than crying in pain, like that chap on our estate. He yelled for a week. You could hear him night and day. He took his time about it . . .'

'What was the matter with him?'

'He was in pain.'

'Didn't they give him sedatives?'

'Apparently they had no effect. I don't know what it was he had. There was shit that came out of his mouth, as though his pipes were mixed up. Poor bloke . . .'

'In cases like that it would be better to help them.'

'He was asking to die, he was suffering so much. The doctor didn't want to for religious reasons.'

'Was it the doctor or the patient who was religious?'

'The doctor. The chap wasn't interested. He couldn't open his mouth without saying "For God's sake, it hurts!"'

'That's proof he *was* interested in God. Even to shout at him.'

'That poor bloke suffered. He was a martyr.'

'He'll be in heaven now.'

'His doctor – you know the one I mean? – well, the church is the only thing that interests him, even more

than God does. He didn't want to see the chap go. He wanted him to take communion.'

'He could have refused. He had the right to.'

'He just wanted to die ... You can debate it all you like.'

'So why are you going to their medical van if you distrust doctors so much?'

'Because the SNCF gets it free for its employees.'

'What about your daughter? And the wife?'

'The little one's growing too quickly. She's flat-chested and white. She looks like a garlic stalk in September. Her nose runs all the time and she sniffs. The wife hasn't said anything, but she wants to have her breasts examined because of our neighbour who had cancer. Anyway, we go every year before Nice. After, we can set off happy.'

'Is Lisou going to Nice, too?'

'Not this year. She came with us the first year, but she got bored alone with us. She doesn't go in swimming, she says the sea's too salty and there are waves ... In Nice, she's afraid that people are looking at her. She didn't dare. Afterwards she came with us for a walk, but she got bored and scared. I don't know what it was she

was scared of. She said she was afraid of the sun, because the sun isn't good for people with red hair.'

'Are you afraid of the sun, too?'

'I stay in the shade and I've got a hat for Nice, a straw one that I bought down there. I only wear it in Nice. On the estate they'd take the piss. The son-in-law called me "Jacques Vabre, the coffee king"[2] when I showed it to him.'

'He's jealous.'

'Perhaps. I lent it to him to go down south. With a hat, you've got shade wherever you are. It's like being under a tree. I'm fine. I put my hands behind my back. Or in front with my thumbs in my braces like this . . .'

He demonstrates.

'Sometimes I feel ashamed and don't know why. I think of my friends on the railways. If they could see me . . . You know, sometimes holidays aren't easy. They shouldn't be too long. They get boring. I miss the garden – I think of my beans that no one's watering, my lettuces bolting . . .'

2 After a famous brand of French coffee.

'You could take the chance to do some reading.'

'I read the paper a bit.'

'No books?'

'Yes, I took one with me, the one by . . . what do you call him? It was you who lent it to me. *Remembrance . . .*'

'*Of Things Past.*'

'Yes, well. I tried, but it floored me, you know. There were too many things at once. They got all mixed up. I read the first page at least six times, and every time I ended up dreaming about watering my garden.'

*

'Heavens! You're painting the portrait of a spud!'

'. . .'

'Life-size. A real portrait from the life. Did someone order it?'

'Yes, it was commissioned by the potato herself.'

'Well, you're not going to make much on that!'

'She's paying me in potatoes.'

'To see you, you'd really think that you're looking at it to draw it as it is.'

'I *am* looking at her to draw her as she is.'

'It's twisted where the spade struck it.'

'Yes, that wound is what I like about her.'

'It probably happened a couple of months ago. You see, she's grown new flesh on top . . . I can bring you nicer ones than that from my garden down there.'

'By all means. But I prefer the ones that have suffered. You see, the wound looks like genitals.'

'That occurred to me, but I didn't like to say. Are you going to do it exactly as it is, round, with that shadow? A potato isn't all that special.'

'But just look at it!'

'However much I look at it, all I see is a potato . . . Potatoes don't seem to agree with you. You're full of strange ideas, like the other day when you said that nothing has ever really existed.'

'Perhaps if I managed to paint clearly, I wouldn't need to talk to you so much.'

'What are you trying to do, exactly?'

'Preserve a bit of time.'

'Come off it!'

'What do you mean, "come off it"?'

'I'm making fun of you. All that with a spud for the pot! If I tried explaining that to my friends on the railway . . .

But why not do a pebble from the railway track? Isn't that just as good?'

'Yes, it's certainly just as good. But it doesn't grow. It's less alive. Although it is certainly alive. Everything that exists is alive. It's inevitable, but it's a question of degree.'

'A stone's alive?'

'Why not?'

'I'll get you some from the railway. Real living ballast pebbles. No fakes.'

'Please do.'

'I'll take them quietly. My friends would wonder . . .'

'I'd only need five, maybe seven, no more.'

'I'll bring you a little bag and you can take your pick. It's not wrong. They won't run off. You can paint them as much as you like.'

'I'm ready and waiting.'

'The ones I'll get you will have seen a fair few trains go by!'

*

'I saw your rabbit this morning.'

'My rabbit?'

132

'The one with the broken ear. He's a tough one. He's got an ear that hangs down – he must have been shot at. The day the hunting season opened, it was as if war had broken out. I was that afraid I turned tail. There were some hunters waiting in ambush on the road. A barricade! . . . And they're none too careful with their kit. They've got guns that look like bazookas. They look like they could go through a tank at a hundred yards. They were all dressed in khaki. About ten burly-looking chaps. Like a commando unit.'

'Did they let you through?'

'Well, they seemed sorry that I was a man. I could see in their eyes that they were sizing me up like I was a wild rabbit.'

'They're not far from the truth.'

'I wasn't proud. You're talking about a weapon that's for shooting poor animals that are cleaning their faces among the clover. Those rabbits are half-tame, you know. You only have to look at yours. They come right up to your feet, you scarcely disturb them at all. They're almost like pets. And those men would shoot a poor creature who falls ready cooked at their feet –

their guns roast them from the inside. They come in their buses and trucks and pretend to fight like they're war heroes.'

'There should be a huntsman's medal for winning the war against the rabbits.'

'Some of them are going to end up shooting each other. It'll be more fun for them than small defenceless animals. It'll come to it, mark my words. Those chaps are getting bored, what with all that gear they don't get to use. Anyway, your rabbit escaped the massacre.'

'I told him he should stay inside in the warm while the shooting was going on.'

'It's also because you're here. The hunters wouldn't dare. But when you're away . . .'

'I find cartridge cases ten yards from the house . . .'

'One day they'll shoot you for their pot.'

'That isn't really hunting.'

'They're taking the air.'

'Do you need a rifle to take the air? Do you have to kill a lettuce?'

'No, quite the reverse. That would stop me breathing the air.'

'You're not a hunter.'

'But I like game on my plate. I'm a hypocrite.'

'You're not alone.'

'I feel ashamed.'

'You can easily get over a little bit of shame, when something tastes good.'

'Come on . . .'

*

'Still working on the spuds?'

'You learn things when you spend a long time looking at a simple spud sitting in front of you like this . . .'

'Hmm. Why don't you do some nice flowers? A nice painted bouquet that'll last longer than one in water?'

'You can go and buy artificial flowers or colour pictures. There's not much point in a painted bunch of flowers these days.'

'That's as may be, but I don't see why you can make potatoes look nice and not flowers, since they're beautiful already. The wife loves flowers.'

'One day I'll paint a bunch for your wife.'

'That'd be nice.'

'There are so many flowers all around every day now –

in photographs, the cinema, artificial flowers, colour printing, on TV . . .'

'That's true, but a bunch of real ones . . .'

'You can have them from your garden if you want . . .'

'What about in winter?'

'I'll do you a bouquet in the snow.'

'In summer they make the house smell fresh. I think pictures are like a celebration, to bring you pleasure at home.'

'A bit like furniture, you might say.'

'If you like. And also for when people come to see you.'

'I don't know what they're for, but I keep doing them.'

'You're never satisfied. That's why you can keep starting all over again.'

'It's like making love . . . No matter how good you are . . .'

'Hmm . . . not always . . . I'm getting on . . . I used to be more . . . vigorous – still, I make the effort . . . What about you?'

'Ah . . . well . . .'

'You'll see. You'll lose it. It hasn't come back for me.'

'It's just . . .'

'Don't worry. It doesn't bother me. Mind you, it never bothered me that much. But we're part of nature. Nature makes you do things that you wouldn't do if you could see yourself doing them. Don't you think?'

'Well, now that you mention nature . . . Do you think that's what it is?'

'I don't know, but I know I didn't invent it. I'd never have thought that up. Neither would the wife . . . and yet . . . well, maybe . . .'

'You're programmed?'

'Hah! Yes. We don't do what we want.'

'But did you dislike it so much?'

'It's not that I disliked it, but at the start I didn't know how to go about it. I was a bit green. No one taught me. On military service . . .'

'You went to the brothel?'

'Where else would you go? You won't learn that stuff at midnight Mass.'

'Nor in the brothel.'

'That's true, but it gives you the gist.'

'The gist?'

'The general idea . . . In the army everyone does the

137

same. You learn what other people do, but there's nothing to say that you can't do it differently. If the first person happened to get it wrong . . .'

'That's how it came about, I'm sure, and ever since then men and women have been trying to correct their original mistake. By what they call eroticism.'

'Rotty what?'

'No, from Eros – love as a game, a way of finding out how it would have been if the first man and woman hadn't got it wrong by rushing or going about it the wrong way.'

'Ah.'

'Ah, what?'

'Just ah.'

'Do you agree?'

'Well . . . that sort of thing's fine for young folk. But it's too late for me now. The railways, the union, and all that digging has made me a bit simple.'

'Not as simple as all that.'

'Well . . .'

'My father and mother, and my grandfather and grand-mother are down there, I think. My uncle and aunt are in the cemetery up there.'

'Here? Are you sure?'

'No, I'm not sure, but . . . I don't come here often. Yes, this is definitely the place. I remember the broken Jesus. They're all down there. Rotted away now for sure.'

'The dead stay around longer than you'd think. When you dig them up they're not necessarily rotten. Just a little bit shrivelled. You'd think they were dried-up or mildewed turnips. Have you ever seen a mildewed turnip?'

'No, but the very thought . . .'

'Don't think about it.'

'A fresh corpse is like wood. Cold and maybe a bit doughy. Like mastic . . . We'll have to spruce this poor grave up. Pull up the dandelions that are coming through the gravel.'

'We should level it out a bit, take out the weeds, set Jesus back up. He's split in two – we can put some wire around him.'

'He's dancing. He looks like he's wiggling his hips.'

'Look! He's moving in the wind!'

'It's a miracle! He's moving!'

'Dig there a bit and freshen up the soil. I'm going to prune the rose. It's overgrown – it needs the barber. Wait till I've trimmed it back, there'll be clippings all over the place. Rake there a bit to make the ground neat.'

'Like this?'

'Gently. On the surface. Otherwise you'll rake up the soil. Just scratch the surface.'

'Poor father. Your son has come to scratch you after so many years . . . Poor mum, watch out for your hair. I'll tickle the bump you used to predict the weather.'

'What are you on about?'

'My mother had a bump, a cyst it was called. This bump throbbed every time there was a change in the weather. That's how we knew the weather in advance.'

'Yes, people used to have their ways with the weather.'

'Now they've got the radio.'

'Come on, get raking – it'll make it nicer.'

'I'm raking as fast as I can.'

'You should throw away all the rubbish. The stones

and the artificial flowers. But not on the graves round here.'

'I'll hide it underneath Jesus.'

'He was a good bloke, that Jesus. He loved ordinary people. Maybe he'd have liked me . . . I think that if he was alive now I'd have come across him on the railways.'

'Jesus on the rails. Sweet Jesus, show us the way.'

'The railway, that is. He would have been just an ordinary railwayman.'

'No doubt about it. And in the union . . . Is that OK? Under there are the bones of grandfather and grandmother, further down. There can't be much of them left. They've been dead forty years.'

'After forty years . . .'

'Though I've seen bodies five hundred years old that were well preserved. They still had flesh on them . . . That was in Peru.'

'It's dry over there. Here things rot more quickly . . . Put the chrysanths in the vase, in the middle.'

'In the middle?'

'Yes, that's better. And then you can put a vase on either side.'

'Symmetrically?'

'Yes, that's best. It's not the place for anything fantastic.'

'Fantasy is alive. Symmetry is dead.'

'That's it.'

'And that makes a monument.'

'A grave's a memorial.'

'In Mexico on the Day of the Dead they invite the dead to come and eat with them. They celebrate the day together, they come to the table. After the meal, they feel good. They tell the dead about all the foolish things they've done . . . Whereas to commemorate my dead, I've come to clean up their graves with you.'

'Your gardener.'

'Yes, so that I'm not alone with the dead . . .'

'Are you afraid?'

'With you here I'm on the side of the living. It's nice with the four pots of heather.'

'Yes, heather flowers at the right time of year.'

'This is the second year that I've come.'

'That's because your time's getting closer.'

'Yours, too.'

'I'd like you to live for ever. You deserve to.'

'I'd get bored.'

'What would you like on your grave?'

'Oh, I don't mind . . .'

'Put some earth there, there's a hole. Rake over our footprints. Here . . . On my grave? Simple: if I had the money, I know what I'd do – I'd have a vegetable garden on top.'

'Underneath you could take care of the roots, and kill the whiteworm that eat your leeks, and the moles. You could give them a hard time, up close, face to face.'

'Two rows of leeks. Two or three lettuces, some peas and beans.'

'You could make the stakes in the shape of a cross. That would be more appropriate.'

'That's an idea.'

'So what's to stop you?'

'The wife. She doesn't want me drawing attention to myself. Though it would give her vegetables for her soup. Meanwhile, I reckon we're finished. I'm off for my soup . . .' *He looks at the two graves we've tidied up.* 'They look nice now.'

'Do you want a coffee to warm you up?'

'Yes, please, it'll make a change from tea. It's not warm this morning in that damn fog. I'll take off my boots or they'll dirty your kitchen.'

'You've got nice slippers.'

'That way I'm not barefoot in my boots. I can't stand socks – they make my feet burn up. I'm only happy barefoot.'

'One sugar or two?'

'Two. I like sugar, though I shouldn't . . . But I don't know what I should like. They say don't eat bread. Then they tell you, no butter . . . When you look at the Dutch, who eat nothing but bread-and-butter sandwiches, you say to yourself: "These people are going to die. They're poisoning themselves. They should tell them. Someone should. We can't just leave them like that . . . committing suicide with bread and butter." The doctor told me: "No wild boar. No partridge. No game at all." As he didn't mention kippers, I didn't bring the subject up. If I'd told him, he would've banned them, too.'

'Kippers are good for your arteries . . . The Japanese eat nothing but, and they have fewer heart problems.'

'I'm not Japanese.'

'You're almost there. You're not lacking much: you've already got the tea, the fish, and you take your shoes off to come into the house. You're a bit Japanese.'

'You're making fun of me.'

'I never make fun of you.'

'The rabbits have been at the lettuces and carrots again. They'll eat the lot if you don't do anything, you know.'

'Do what? Have a word with them? Write to them?'

'Put up scarecrows. Make sure they can't get into the garden.'

'Would that work?'

'No, they'd get through anyway. Underneath. Even if you bashed a few of them, they'd still come up to your feet. They're not wild. They look at you with their ears pricked. They wait a minute and if you don't do anything, they stay.'

'That's what I like. Animals roaming free: lions, cats, rabbits, giraffes, all the animals in nature together. Paradise.'

'No, thanks, no more coffee for me. It stops me dreaming of paradise. If I can't sleep, I count my lettuces in my head. I always miss some out and have to start again.'

'Yes, we dream of the things we desire. It's not surprising that we dream of paradise. We've never dreamt up anything better . . .'

'We'll chat again up there. I'll wait for you to the left of the entrance.'

'You can make me a nice hot cup of coffee and—'

'Don't worry. I'll keep the coffee hot.'

'Not too hot – "coffee boiled is coffee spoiled".'

'I'll be to the left of the entrance with a camping stove.'

*

'Do you work even on Sunday?'

'What about you? Aren't you going to the fair?'

'I'm going fishing. The fair's too full of people.'

'It's supposed to be.'

'Yes. There have to be people at a fair.'

'You're going to see your old friend, the fish, down by the river.'

'Do you know what I was thinking about? All the

people at the fair who're drinking, well, they have to pee, and the rest . . . well, I was thinking that all that must amount to quite a heap of manure.'

'All the dung of the fair.'

'That's not bad. But it must burn the plants with all that booze in it. I calculated that it would make several square yards in two days . . . perhaps five.'

'I wanted to ask you something. On the railway track, when the train goes by . . .'

'Yes?'

'I wanted to ask . . . do you see traces?'

'Travellers' manure? No, you hardly see anything. It gets chopped up because of the speed.'

'But over time . . . for example, people who take the same train at the same time, eat at the same time, go to the loo at the same time, at the same place . . . after ten years, there must be a bit of a pyramid?'

'After ten years it's destroyed.'

'It's biodegradable, then.'

'It's natural. You do see some mess on the track, but it's chopped up small as shingle, little bits . . . and anyway in summer the flies land on it. You see little clumps of flies . . .'

*

'You know what?'

'Now there's a question!'

'If I'm not disturbing you, I don't want to put you to any trouble, but if you didn't mind . . .'

'Yes?'

'I wanted to ask you to do me some paintings – on bits of cardboard or whatever you like – of things that would give me pleasure, things that I'd like to have with me. Perhaps also things I haven't had but that I'd have liked. You know the sort of thing I mean. As if you were doing it for yourself. It doesn't have to be finished. Just a little bit of colour so that I remember.'

'Tell me why.'

'In case I lose my marbles . . . But if it's a nuisance . . .'

'I didn't say that.'

'It doesn't have to be very big. On little bits of cardboard, the size of a book. I'll make a little parcel of them to keep with me, just in case.'

'I'll try to do it.'

'You know what I think about. What I like.'

'Do I have to draw a woman? Several, perhaps?'

'Hmm, you know. Do it as if it was for you.'

'If it were for me, I'd do—'

'Do mine for me. She's tall, a bit pale, with nice eyes. Well, I think she's tall and has nice eyes. Grey eyes, I think. Or blue . . . you know, I don't know any more what colour my wife's eyes are! When you get . . .'

'I'll come and see your wife's eyes.'

'If you get the eyes right, the rest doesn't matter.'

'Ah.'

'It's not easy talking about this . . . Just do what you can. Do what's best.'

'We needn't talk about it.'

<p style="text-align:center">*</p>

'I almost ran into a funeral on the way here. I found myself face to face with the hearse as I was coming down from the cemetery on the path, the one they call the "shitty path". I didn't expect anything and then all of a sudden I was right up against the hearse! I almost ran into it . . . I didn't know where to put myself. I was so embarrassed, what with my brightly coloured scooter . . .'

'It can't wear mourning.'

'I was dressed like this. In my scruffy boots. I couldn't go forwards or backwards. I was slap bang in the middle of the family. The worst thing was, I knew all of them. It was the Peuchs – their old man's died. He didn't hang on long after his wife. You know who I mean? Old man Peuch was a good sort. He had sort of curly hair, a bit of an Afro look. An Afro from round these parts.'

'Did you keep your helmet on?'

'Well, I couldn't take it off. It would've looked like I was doing gymnastics. They looked again harder to see who it was. The younger son recognized the scooter. I made a vague sign of the cross so as to do something. I didn't know what else to do, with my black visor and this pot on my head. It looks a bit too cheery with the red band round it and the shark's-tooth design, like a mouth that's laughing. I was so embarrassed. I should have gone to the funeral, but I never go to them. I visit the house but I don't go to the Mass or to the cemetery. I don't like all that fussling.'

'Fussling?'

'You know. Making a big fuss.'

'What will you do when it's your turn?'

'The proper thing. The wife'll put me in a suit. The one I got married in. It's navy with a stripe. I don't wear it often, even in Nice.'

'I've just realized who the dead man was. He's the one you used to see going out with a white stick?'

'Apparently his sight wasn't that bad, but since he got a pension . . . They say that the blind can see and the deaf can hear. Some people would give their eyes and ears for a pittance of a pension.'

'Well, it's put an end to his jealousy.'

'That's true. He was jealous of that poor wife of his, the big woman who'd had so many children that she looked like a sow. He was jealous even though she looked like that, even at his age.'

'It was true passion.'

'He'd hit anyone with this stick if they went anywhere near her. In the hospital he nearly thumped the doctor. He probably couldn't see that well. If he'd been able to see his poor wife properly . . .'

'You see – he deserved his pension . . . It's a beautiful love story.'

*

'I've brought you a jacket like mine. A rubber one. You won't get wet if you go mushrooming in it. The water doesn't get through.'

'You shouldn't have.'

'I get given them. They're work clothes for the railway. It doesn't cost me anything. I can give it to you as a gift. If it fits you, it's yours. I've got two other new ones already.'

'Thank you. I'm embarrassed.'

'Don't be. It's not worth it. I wanted to bring you some shoes like mine, too. They're solid clodhoppers! I can't remember how long I've been wearing them. I don't know if your feet are the same size as mine?'

'I've got small feet.'

'My feet aren't that big, either. If you like them I'll bring you a pair. I've got some in the cupboard doing nothing. The son-in-law doesn't want them. They're not good enough for him. But if you like them . . .'

'They look like good shoes, but I'm embarrassed that you're dressing me . . .'

'Oh, if you like them, just tell me. It would give me pleasure and it doesn't cost me anything. Well, almost

nothing . . . We're entitled to a pair a year, and also a rubber pair. And we get seeds for the garden through the union.'

'. . .'

'I don't use much up; I've got enough left even for my retirement. And I like wearing what I had on the day before. Clothes which are "made" for me. When you put them on the first time, they're stiff, but a day later they feel fine. You'd think they get to know what movements you're going to make . . .'

'When it's hot on the railways, do you take your jacket off?'

'Not often. Sometimes we stay in our leather waist-coats, but we prefer to stay covered up. Because of the sun and the sweat. It's also a question of habit. In my day we didn't stroll around half-naked like they do today. Mind you, it's not bad, seeing the young people on the beaches. But I keep my jacket on. Anyway, my skin peels. You see some people who're baked like bread . . .'

'I like to feel the sun on my skin.'

'It probably does no harm, but it cooks white skin. Negroes have nothing to fear – they're already black. They're made that way for the sun.'

'And white people for the snow, and yellow ones for mayonnaise . . .'

'Nature has got it right – and we get hungry when it's time for soup. I'm off.'

'And now, thanks to the jacket and the shoes that you're going to give me, I'll be hungry at the same time. The habit maketh the monk.'

'Might well do.'

'My neighbour on the estate's gone mad.'

'. . .'

'It came over him all of a sudden – he wanted to kill his wife, his sister-in-law, and his daughter . . . The shouting! You'd have thought there were thirty of them in there. The sister-in-law was the one who was shouting the loudest.'

'How many of them did he kill?'

'He didn't kill anyone, but he shot at the sister-in-law, missed, and pierced a kitchen pipe.'

'You've certainly got plenty of distractions!'

'I live right next door so I know him. Félicien isn't a bad lad. Ready to help out, kind, a little bit grumpy maybe. But not the sort to kill people. I don't know what got into him.'

'Did you try to stop him?'

'I went to the door but it was locked from the inside. I said: "What's going on? Do you need anything?" But nobody answered.'

'And then?'

'We listened. The shouting went on. All of them at the

155

same time. The two women and the child. The girl was shouting, and then she started crying.'

'What makes you say that he'd gone mad?'

'It was the sister-in-law who was shouting: "Félicien's gone mad! He's going to shoot us with his rifle. Help! Help!" It didn't seem very Christian to want to kill everyone, even his sister-in-law . . . When you look at it closely sometimes, mad people say true things . . . We had a chap working with us on the railways who people said was mad. He'd say "It's raining! It's raining!" when the sky was blue from top to bottom, with not a hint of a cloud in sight. He'd go and take shelter under his rubber coat as if it was raining.'

'That's not necessarily mad. It let him have a rest.'

'He was scared of storms, too. They made him jumpy. We had to keep an eye on him on stormy days, otherwise he'd have gone and thrown himself under a train. He was afraid of the electricity in the air, and the wind. He said the wind spoke to him.'

'The Kanak people say that the ancestors speak when the wind blows into a shell. It's their ancestors' voices that they can hear.'

'Maybe that's true, but a railway line with express trains going by isn't a place to hear the ancestors. It's dangerous.'

*

'How are you?'

'Fine, thanks.'

'Still full of beans?'

'Hmm, I appear to be.'

'Appearances are what count. When you don't look the part any more, you're done for. The body's still looking sound.'

'It's the body that's given up. Otherwise the head's just the same as before. No fuller and no emptier. I forget people's names, mind, and I can't remember what I did yesterday . . . But apart from that . . . It's true that it's not overstuffed in there. It moves about as though there were nothing round about it. But it's done me this long, so it'll do. I'm not going to change it now.'

'What are you complaining about, then?'

'I'm not complaining about anything, but at my age it's not like it was before. And now it's the will that isn't so strong any more. When I was young, in the mornings

I felt like I could take on the whole world. I had strength to spare. I used to punch the air to get rid of the extra energy, to let off a bit of steam. Now there's nothing left over. I've got enough, but when I carry a stone in my arms, a big one like that boulder there, well, I feel like I'm going to drop it, like it's going to fall at my feet.'

'Well, just as long as you can lift stones and pay your compliments to the wife.'

'That's the same as the stone. It feels like I'm going to grind to a halt halfway through. Anyway . . . Doesn't that happen to you?'

'It's not easy to say. I don't lift a lot of stones. And as for the other, well, we're not alone. Or we're more and more alone, I mean. When you grow old desire begins to get weaker.'

'And the pipes and the workings have a screw loose and some of the parts are worn out. Sometimes you want to, but don't have the strength, and at other times you've got the will, but the machine has broken down.'

'But we can still dream about what we used to do.'

'Or didn't do. And now . . .'

'Women . . .'

'Oh, women . . . Back then in the countryside, there were some you could look at, but not all. And when I was out working, it was the same. You have to learn not to want them all. You soon get used to getting a slap. You learn what's there for the taking and what you've got to steal. The marks remain. I have trouble talking about it all. Even the women on the television are too much for me. I daren't look at their big thighs. They look like animals. Beautiful animals, mind you, but I'm not used to it. It's not for me. They're too tall, those lasses. I'd only come up as far as their tits. It's no one's fault, I suppose. Meanwhile, the days go by and there's nothing but those big thighs . . . And anyway, that's not for me at my age. Not really. I can't shed much light on that whole business . . . Women are like a garden in the dark to me.'

'How are you?'

'Hmm.'

'Not so good?'

'Not too good.'

'Are you ill?'

'I don't know. One of my arms hurts – I can't hold the left one up.'

'You should go to the doctor's. Though if that's all that's the matter, it's not worth it. I saw my doctor the other day – for quarter of an hour. I didn't have time to tell him where it hurt before I was out the door. He filled in the forms. I waited in silence. He didn't ask me anything. Then he says: "How are you?" "Fine," I said without thinking. "Good. Are you sleeping well?" "Eh . . ." I didn't have time to reply before he was seeing me out, asking me how the wife was doing. I said: "Fine, thanks, doctor, she's fine." And he was steering me by the shoulder towards the door. It was over so quickly that I thought he might have mistaken me for his previous patient.'

'What was wrong with you?'

'I've got stomach-ache. From time to time I feel like it's bunged up.'

'It'll be the kippers clogging the pipes.'

'I don't know.'

'Why do you say it feels blocked?'

'It's just a feeling I have. It's hard. Swollen.'

'Can you shit OK?'

'Sometimes.'

'Do you go several days without?'

'Sometimes it's not the way that you'd want it. It doesn't happen on command. We're made in a strange way, what with that huntsman's bag. We don't know anything about what goes on inside.'

'You know what you put in it.'

'I eat the same as everyone else, but I'm the only one in the family who's having trouble . . . I'm not as young as I was.'

'But you've been eating kippers every day for years.'

'I eat kippers here and at home I eat soup.'

'Do you like soup?'

'It's my favourite. In winter when you come in from

161

the cold. It's liquid and it's solid at the same time – it's good. But I don't like talking about all this . . .'

*

'I didn't come yesterday. My stomach was hurting. I really think something's bunged up this time. The doctor thinks there's some blockage.'

'Do you have a temperature?'

'Oh, I don't know. Lisou broke the thermometer, and I don't like that thing . . .'

'You can put it under your tongue.'

'That's not clean.'

'You clean it in alcohol beforehand.'

'Hmm, maybe . . .'

'You're ill. Stay sitting down. Have a rest.'

'Thank you, but I have to get it to come down. If it's bunged up, moving about will help it unbung. It draws it . . .'

'Have you been going to the toilet?'

'I went a few days ago. Since you spoke to me about it, I've been taking note. I read my paper in the toilet . . . Anyway, I could give you dates, but it's not very interesting.'

'Are you reading the paper every day?'

'Not for several days. It's always the same thing – wars, fires, crime, theft.'

'Read something else, then.'

'At least it gives me something different to think about. It unbungs my head . . . and as long as the disasters are happening somewhere far away, like Chile or Pakistan, they don't seem real. Sometimes they don't give a damn about the punishment they take in those hot countries. Hundreds and thousands at a time! Floods can do for hundreds of thousands at one go. It makes me laugh, though I wouldn't dare admit it. But you think – they must be bloody stupid not to learn to swim when there's so much water about. Even in peacetime – if there's a fire in China it burns thousands at a time and then the water drowns as many again. We can't under-stand that here. We reckon it can't be much fun being Chinese or Pakistani or Chilean.'

'Meanwhile, you're the one who's been blocked for four days.'

'I've got an appointment with the doctor. He'll give me some drain-cleaner like the last time. He said:

"If it happens again, you'll have to see a specialist in Brive."'

'A plumber?'

'That'd be as much use as a doctor. The wife's coming with me. We'll go on the train. She's seeing the specialist herself.'

'Is she blocked too?'

'She's under the weather. She gets turns. It's her age. She has hot flushes and suddenly her legs are cold. It's "the change" – she's going a bit loopy. She shouts at me for no reason. Apparently I make a mess with my scooter, and put grease and dirt on the hand towel, and my boots leave clumps of soil on the lino. No matter how much you bash them, some of the earth stays stuck to them, and then in the heat of the kitchen it drops off in lumps. I can't deny it was me because the wellies make a waffle pattern in the mud. Then I get a telling-off.'

'Do you think the doctor could give you some medicine to make her tell you off less?'

'That would be good.'

'Did she use to shout at you less?'

'Not so much. As she's got older, instead of saying that

it doesn't matter, that we'll be dead soon and in any case it won't change anything, she gives me an earful.'

'What for?'

'Everything. For being untidy, for what I'm wearing, getting home late, not looking well, not doing things the way I should, never taking my time, not paying her enough attention, rushing around the whole time . . . I don't do anything like I'm supposed to. Sometimes I think to myself, if what she says is true, I'd be better off dead . . . It'd clear some space. It's true. When you get told off like that, you start to wonder if you're in the wrong . . . You get tired being that way, tired of just being. And when you're shaving and you look in the mirror, your own face disgusts you. And it's only going to get worse.'

'Hmm . . . you don't realize . . .'

'She does. She compares . . .'

'You stay young inside.'

'Maybe. We're not finished in our heads. Maybe that's why I rush around. If I stopped rushing around one day, it's as though the young man I once was would catch up with the old man I've become . . . and would probably kill him.'

'Don't forget to see your doctor. I don't like seeing you like this, with stomach-ache, and not eating your kippers.'

'I don't fancy them. The very thought . . .'

'Don't think about kippers, then.'

'No, I'm going to think the way I did when I was young. I'll catch trout in the stream, play in the woods, look at girls . . . Maybe that'll unblock me . . .'

In September he went to the clinic. On the phone his voice is weak and distant and he can't hear me very well.

<center>*</center>

'I'm not too good. The pipes are still bunged up and they don't want to unbung. They're going to operate. If you could see me – I've got wires everywhere, like a telephone exchange . . .' *A pause.* 'Have you finished your . . . the things you were doing in your studio, your bits and bobs? They was nice. I think about them sometimes. The days and nights are long here. I spend time in your studio sparring with you in my head.'

'We'll do it again for real.'

'If we do, you can paint my portrait.'

'I'll paint you on your scooter.'

'Hmm . . . you can draw my remains.'

<center>*</center>

'Hello. Is that you?'

'Who's that?'

'Is it you?'

'Oh, it's you. It's good to hear your voice.'

'Yours, too.'

His voice is trembling. Maybe it's a bad line.

'So, have they opened you up?'

'I don't know what they were looking for.'

'Did they find it?'

'I don't know.'

'I don't want to tire you out. I just wanted to hear your news.'

'You're not tiring me. But it's not much fun being like this. If you could see this tangle . . . it's full of cables and wires. It's got a drain, a phial, and a bag for my business. I don't know how I'll end up. But they're looking after me.'

'Are they being nice to you?'

'I can't complain.'

'I'm tiring you . . .'

'No, no, it's nice to hear from you.'

'I'll call again soon to find out if they're going to take out your cables.'

'I'd be delighted to hear from you.'

'Take care. And get well soon!'

'Thank you.'

'Be patient.'

'I've nothing pressing to do. I can certainly be patient.'

'I've told your fish to wait for you.'

'Tell him I'll be back. No, don't tell him. I'll take him by surprise.'

'I won't tell him anything. Don't worry.'

'I'm counting on you.'

'Bye.'

'Bye.'

<p style="text-align:center">*</p>

'Hello? Hello? How are you?'

'Ah, it's you.'

'Yes. How are you feeling?'

'Oh, I don't know. They opened me up again. I don't know what they'd left inside. Maybe they forgot their pliers, or an umbrella.'

'Did they find them?'

'I've had enough of it. That's three times I've been through it. Three times I've been opened and shut like a drawer.'

'Once you're closed up again, it'll heal by itself.'

'I've still got the equipment – the blue and red cables.'

'How do you feel?'

'Not great. Good for nothing, what with my legs and my stomach.'

'They didn't cut your legs, did they?'

'They do what they like and cut wherever they think best. "Are you OK?" he says. "You're OK, you're a tough one." "Ah, yes, doctor, that's me." "Bye," he says. "I'll come and see you tomorrow. I can see you're doing well." I don't know how he can tell . . . Are you ringing from Paris? I can hear noises . . .'

'Yes, I'm in Paris.'

'And here I am going on. I'll be quick.'

'Take your time and tell me how you are.'

'I'll tell you in a week. For now, they've disconnected my intestines. What can I say? I have to go in a bag. I don't have an arsehole any more.'

'What?'

'My silencer. They've rerouted my exhaust. That's the worst of it. He's promised to reconnect it afterwards.'

'That's good.'

'Yes, the doctor said: "I swear that as soon as I can, I'll have your backside back in place. For the moment, I'm

installing services at home." But you get used to it. You can get used to almost anything. If you could see me now . . .'

'When you've got your exhaust pipe back, you'll be able to step on the gas . . .' *I'm a bit ashamed of that joke.* 'You'll be as good as your scooter.'

'That's true. It's good to hear from you. It takes my mind off it. What about your field? Have you finished drawing it? You're lucky – you can do what gives you pleasure with a pencil. Draw me an exhaust pipe . . .'

'Don't you want a lettuce?'

'If you like. For the moment, it's my exhaust that's giving me gyp . . . It's funny, all the same, when you think that we do that just out of habit. We don't know how lucky we are.'

'You're an old philosopher! Goodbye. Take care.'

'What did you call me?'

'A philosopher.'

'Filochard, more like.'[3]

3 After a character in a comic strip, one of the members of the 'nickel-plated-feet gang'.

'Goodbye, Filochard. Be good and patient. You've got time on your side.'

'Thank you. Goodbye.'

*

'I can hear you better this time.'

'Are you feeling better?'

'Yes, thank you. A bit.'

'Are you getting out of hospital?'

'Not yet, but they've got me on a longer leash. I can go for a walk down the corridor and wander around as much as I like. My stomach's folded in a cotton wadding. I've no muscles left. If you could see it – my intestines churn about like snakes in a bag. They move all day long. You wouldn't believe how they work. They're powerful, those things. They churn around and make a noise like a washing machine.'

'Are you getting bored?'

'You know me. Any little thing can keep me amused. Looking at an ant, or the light on the ceiling. I like everything. And the wife visits me. The son-in-law came yesterday with my daughter. There was quite a crowd. And you ring me. I haven't been abandoned.'

'What about your scooter?'

'It hasn't been in to see me. It's in the cellar. I got its news on Sunday. Apparently it's fine.'

'And they're not talking about any more operations now?'

'The doctor said he wouldn't open me up again. They've put Teflon on my stomach, under the skin, like on a casserole. Seemingly it's a Teflon mesh, like a trellis.'

'So your larder will be safe.'

'Yes, I'm going to raise rabbits on the top.'

'That's good. Well, bye for now. I can't hear you very well. The line's crackling.'

'That'll be the rabbit.'

'Bye now.'

*

'Hello.'

'Is that you? I knew straight away that it was.'

'Merry Christmas and a Happy New Year!'

'Same to you. And your good health most of all.'

'Have they let you out?'

'Only because it's Christmas. Otherwise I'd still be there. It's better at home. I get less bored. What with all

173

those old folks snuffing it . . . And some who're not so old. And the ones that groan . . . There were two of us in my room, but the other chap couldn't speak. I don't know what he had, I couldn't understand him at all . . . and he didn't seem to be able to hear. It looked like a butcher's apron in his bed. All stained with blood. Probably a good bloke, who knows . . . He'd make signs to me with one hand.'

'How's your health?'

'I'm getting there, but it's hard. The connecting pipe, the tank, the tyres, the brakes, they've all taken a knock. I'm on crutches. I'll be in the garage for a fair old while.'

'You'll get there.'

'Hmm, I've been through the wars. They've taken away a fair old amount. My bag of snakes is wrapped up in cotton. I don't have any skin on my stomach and my hip's seized up. But I can't complain – least I'm not a goner, as they say.'

'What about your scooter?'

'It's like me – in the garage. But in theory it's still working, thanks.'

'It'll be waiting for you.'

'Well, it'll have to be patient for a bit. Are you phoning from Paris?'

'Yes, we're spending Christmas here.'

'I won't be seeing you this time, then.'

'In the summer.'

'I'll come up and watch you drawing your field and your potatoes . . .'

'I'll save a space for you.'

'I can imagine myself there. What you do is beautiful.'

'Wait till you can see it for real.'

'I won't fret about it.'

'See you in the summer. Get well soon.'

'Bye.'

A few months later . . .

'Hello, it's me.'

'It's good to hear from you. It's been a while. How are things? How are you? And the wife and children?'

'What about you? You're the one who's ill.'

'I'm fine, thanks. I'm feeling better. What about you?'

'I'm OK, more or less.'

'I won't go into it, but I can't complain. As long as I am here and not in too much pain.'

'Are you in pain?'

'Well, I can't say I'm in pain exactly, but I have trouble walking. I limp – drag my wounded leg. I'll have to do what Fanguin did and attach a rope to my leg and pull it along like a dog. I drag my foot. It's shorter than the other one by an inch and a half, apparently.'

'Shorter? Has it shrunk?'

'It's an inch and a half shorter. It's the one that had the arthritis in the hip. It seized up and now it's shorter. I have to support it, otherwise I'd fall over.'

'And what about your gardening?'

'Soon I'll only have one garden left. The one by the river will be finished with in the spring.'

'And what about your fish? The big one.'

'It'll be him who catches me one of these days. If he tugs on the line hard enough, he'll pull me in with him. He'll have me in his soup pot. I don't go fishing very often. But I know he's there. I can see him. And he knows me. I hardly taunt him any more. I wish him a good morning.'

'And the wife?'

'She's limping just like me. Even with the same foot – we're both limping on the same side, so that way we don't bump our heads together.'

'And are you going to Nice?'

'No, I'm not going this year – we're going to Lourdes.'

'Are you in need of a miracle?'

'Oh no.' *He laughs.* 'I don't really believe in miracles. No, we're going on a bus trip. We'll go to the mountains. It's worth a look. It's beautiful up there. The air's clean. Mind you, when it's drizzly you don't see much. But we like it. The excursions aren't dear, and it makes a change.'

'I'm happy to hear you're OK.'

'Oh, I'm growing old slowly. I can't complain. Come and see me.'

'You'll be my excursion.'

'I'm just as worth a visit as the Pic du Midi!'

'Are you there?'

'Come forward a bit. I'm behind the beans.'

'I saw your scooter by the river so I came down.'

'It pulls me around.'

'Isn't it a bit dangerous?'

'With the cotton there's no risk. I'm careful. I've still got my snakes writhing about.'

'Do you work kneeling down?'

'I haven't got any muscles left, so I can't pull on my stomach any more. I've made myself knee-pads from a potato sack, and it's fine. I've cut rubber from tyres to hold the bags in place. They stay put. The hardest part's getting up again.'

'It's the Prince of Monaco's garden you've got here.'

He laughs.

'It's not bad this year. The princess is happy – she can make some good soups. If you want some vegetables, don't be shy. Look at the chard – you can take some, it's nice and tender. Do you want a lettuce? Here, take one of these. And what about some peas and beans? I'm going to pull them up tomorrow. I've had enough of those beans. I'm not all that fond of them.'

'Your garden's like a vegetable museum.'

'You're pulling my leg.'

'No, it's beautiful, with its giant vegetables, all well tended and in straight rows.'

'They are my work and I give them away. It's what gives gardeners pleasure.'

'You're more of an artist than me.'

'Yours will last longer.'

'Yours has a purpose . . . When I think back to the state you were in . . .'

'I laughed in death's face. I'm like that old woman during the war who kept putting out a fire with a saucepan, all the time the Jerries were trying to set fire to her barn. Every time they tried, she'd put it out. They'd start again and so would she. And when they had a go with their flame-throwers, the old dear threw water on the flames and gave them an earful. In the end they lost interest and went away. But the old woman ran after them and kept shouting.'

'She was living in a different story from them. The soldiers turned back into children because she stayed an old granny.'

'Well, I did the same with death.'

'You threw water on him . . .'

'I didn't say anything. I didn't complain. I thought about what I still had to do in my garden, with the beans and the lettuces. I shouted at death and he went away without understanding. He wasn't used to that. Maybe if I'd just spoken to him, I'd be with him instead of here talking to you.'

'Was it the garden that saved you?'

'The garden, the wife, our travels. I've still got things to do. The pipe was blocked. The doctors just had to unblock it. I needed a mechanic, just like my scooter. When it's not working, I repair it and then it goes again.'

'And now?'

'It's OK. I can even ride my scooter as long as I don't fall on my arse. I don't have a stomach, the muscles aren't like they were – I can't pull on them, there's nothing left but skin. It's hard in the garden. At the beginning I knelt down to do the weeding, but digging isn't easy. I got the son-in-law to help. It works, being on your knees for planting, and weeding and watering, with old sacks attached to your knees with belts. It's just a matter of getting used to it. You can see better – you're closer.'

'And from close up things are even more beautiful.'

'One day I'm going to have to give this garden up. I used to have three, counting yours. But that was too much. Too much work and too many vegetables.'

'Mine's done with. You were my garden. I wanted a priest's kitchen garden so that I could watch the vegetables grow. I'm happy I saw it. Those courgettes, cabbages, pumpkins, lettuces . . .'

'Ah, the pumpkins are going to be good this year, but I can't lift them. They're too heavy for me.'

'Will you come and see me?'

'If the scooter is willing.'

'The brambles and the moles will give you a guard of honour. Your mole's getting bored without you.'

'I think he won.'

'You're not going to let him.'

'Don't forget your vegetables. Take them. They'll only go bad. Me and the wife can't get through them all. I give them away on the estate. Help yourself.'

'A gift from the artist.'

'It's my pleasure.'

He is sitting under the lime tree. He's still a bit pale, still convalescing. He came on his scooter.

*

'Your garden's full of weeds and brambles. You've got a mole in the field. Being ill isn't a good idea. That damned mole . . .'

'Your old enemy.'

'You can't see the raspberry canes any more – nothing but pumpkins . . . And the grass has turned to undergrowth. When I see that and the way I am . . . no stomach, arms given up, legs like matchsticks . . . Ah, it'll never be the way it was before, never . . . Oh well, I mustn't complain, I'm already a bit better.'

'As long as you come to see me from time to time.'

'I'll come whenever I can, just so long as my scooter keeps going. I like it here and I prefer talking to you to, you know . . . her indoors.'

'The other day you told me you'd been talking to her.'

'Now that you're asking, I've gone a complete blank. I don't know if it really happened or if I dreamt it – when

183

I was telling you I could visualize a corner of the house, I could even see the kitchen tiles. I was speaking my mind. I even got angry. When I got back home, I looked at the place – and it was just a corner of the room where a pipe runs over the skirting board.'

'A scene of domestic plumbing . . .'

'So maybe I dreamt it. I've been dreaming a lot.'

'Has it happened often?'

'Maybe. I'm not sure.'

'When they put you under anaesthetic?'

'I can remember everything and nothing. I can hear the doctor talking, but I can't remember exactly what he said. I could hear him, I could understand, but it didn't register.'

'You're not dead, that's the main thing.'

'No doubt.'

'Apparently you see God in lights.'

'Not much chance with me. Right – it's time for my soup.'

*

'You talking about God's been bothering me since yesterday. I've been thinking that maybe if He was called something else . . .'

'Call Him what you want if you don't like "God".'

'Hah!'

'"Hah" would do, or "Nothing" or "The Great All" or "Tutu" or "Wahwah" . . . that works.'

'That's not the question.'

'What is the question?'

'The question is . . . I don't know how to ask the question. It's a bit woolly. I tell myself: "Maybe there *is* something" and then I think "Why *should* there be anything?" If there isn't anything, it makes me feel sad. But if there is something, I don't know who or what it is. So even if He exists, I'm no further forward.'

'Yesterday, I was just asking if, in your dreams or during your operations, you'd encountered . . . There are people who've seen . . . who've had the feeling that they were getting close to something important.'

'You're asking me for my report. But I don't remember very well. I can't remember anything.'

'So you're not sure that God doesn't exist?'

'No, but I'm not the one asking the question.'

'Do you mean that God is a question?'

'I don't know. If we don't ask ourselves the question, it

doesn't come by itself. All I know is that I've lived without asking it.'

'You're not much of a believer. As long as you have your kippers!'

'I've had the kippers and now I've got the question.'

*

Away from the women, he showed me his 'bag of writhing snakes'. With his fingers under his jumper he mimed the intestines under the skin protected by a band of cotton.

*

'I can't lift stones any more or even hold a spade. I thought that would come back . . .'

'Still, you've got your knees.'

'That doesn't make me any taller . . . And it hurts – I've got calluses.'

'Those are pilgrims' calluses. They count up in heaven. Just say you got them praying.'

'Meanwhile, you need to find someone else. I can't do your garden any more, or cut the hedge or anything. I'm good for nothing now.'

'We can wait a bit longer.'

'Hmm, this bag won't be growing back . . . and I don't

like seeing the garden in this state. I dreamt about it. The brambles were as high as the house and they were choking me like boa constrictors.'

'What about the mole?'

'Don't worry about him. I'm going to cook his goose. But when I see what I've become . . .'

'You're still holding together.'

'I've come to joking about God.'

'It was me who spoke to you about that.'

'It's a sign that I'm done for.'

'Done for?'

'As far as the garden is concerned.'

'The mole and the brambles will wait for you . . .'

We're sitting in the kitchen on either side of a table covered with a floral oilcloth. On the wall is a calendar. On the door, photos of the children when they were young, and holiday postcards. There's a photo of the caravan with the Akileïne ad.

*

'Come on in.'

'Just for a minute.'

'Stay as long as you want.'

'They're waiting for me.'

'Whoever's waiting won't run away. Only trains leave on time.'

'OK, just for a few minutes, for the pleasure of it.'

'That's what I meant. I get bored doing nothing – a bit of company does me good.'

'I'm pleased to find you in good health.'

'The winter was hard.'

'It's hard for everyone.'

'Hmm, every winter is that little bit harder.'

'How's your wife?'

'She's gone to see our eldest daughter, the one in

Brive. She goes once a month. Seeing the lights makes a bit of a change for her, especially at holiday time. You know how we like shiny things in the country.'

'Sequins . . .'

'It's you who sees that . . . Listen, you should take the chance now that it's winter to get your trees cut. I can't look after them any more. In my state, there's no chance of me climbing trees, or walking or anything.'

'I don't want to replace you.'

'You'll have to.'

'Who with?'

'You'll find someone.'

'I haven't so far.'

'And meanwhile, everything's still growing. Brambles everywhere. And trees blocking out the light.'

'We did try to find someone, but the first one who came – I won't mention his name – fell down dead drunk in front of the door. The next one cut down the apple tree, a sainte-germaine it was. We showed him the dead apple tree and the good one, and he cut down the wrong one. Right down to the ground. The sainte-germaine, too . . .'

'You could find one who can stand upright and can tell a dead tree from a live one.'

'I haven't come across one yet. Listen, I need to buy some muck for the rose bushes . . .'

'You need dried ox blood.'

'Ox blood for roses?'

'They like that. Roses are carnivores. Red roses are full of blood.'

'I've got to go. I'm keeping you back. Think of my roses from time to time. It'll help them.'

He wants to have the last word and so do I. It's like a farewell symphony whose ending never comes.

'Muck! Muck for the roses!'

'Blood! Ox blood!' *I shout in the stairwell.*

'Put what you like on them!'

'Shit?' *I say.* 'What about shit?'

'What shit?'

'Shit for the roses?'

I'm on the ground floor.

'That'll make them smell nice!'

'They stink already!'

*

I talk to him from downstairs, looking up, and he replies, with his head over the fifth-floor balcony. I go this time, giving him the last word. Or just about . . .

I call 'Goodbye' and start the engine. I can see laughter in his eyes and his sly look, his face supported in the crook of his crossed arms, as he leans on the balcony.

His garden on the banks of the Vézère is abandoned now. According to a neighbour, he has only kept on the one near the estate. I go there – it's emerald green, well watered; the plants are growing in the shape of a church nave. The beans are so tall that they almost hide the sky, the peas are hanging down above the canes. I can hear music, possibly Mozart.

<div align="center">*</div>

'Where are you? Hey! Is anyone there?'

There's a noise from the ground and then a muffled voice.

'I'm here.'

'Where's here?'

'Come a bit further, behind the beans . . .'

He's lying on the ground on a potato sack.

'I'm weeding the lettuces. I can see better close up.'

'Are you working lying down now? Like gardening in bed?'

'I used to be able to garden on my knees or on all fours, but now that hurts my hip. And with these glasses I can't see too well. But lying down, I'm fine. It doesn't pull on my stomach and my arthritis doesn't hurt.'

I sit down beside him on a black plastic bag.

'Are you listening to Mozart?'

'That's my little radio. I take it everywhere with me. It keeps me awake and tells me the time . . . Lying down like this sometimes makes me fall asleep. But I like this sort of music . . . I leave young people's music to the young. Their music's lively, of course, but what I need is a rest.'

'This is Mozart.'

'He's the one who could play music when he was really young? He's good. Better than I could do.'

'Better than me, too. You're good with your vegetables. You're an artist in your own way. Can you garden lying down?'

'Today I'm lying on top of the weeds. Maybe tomorrow I'll be able to pull them out from six feet under.'

'I promise to come and see that.'

'There won't be anything to see.'

'I'll come and make conversation with you. Sometimes I talk to you even when you're not there.'

'If you knew the things I tell you . . . But when you're here, they go out of my head.'

'You're shy.'

'Hah! Maybe a little.'

'How's your health?'

'Lying down's all right, but standing up is hard. The doctor wants to operate again – he's always wanting to operate – but at the hospital they decided that I'd had enough of that for the moment. So I limp along with my stick, walking on three legs, and less and less quickly. Soon there won't be much left that works.'

'Your head.'

'"The head alone doesn't make a good soldier." Or a good gardener. What about you?'

'I'm fine.'

'And the children?'

'They're fine. What about yours?'

'Fine, thank you.'

'The wife?'

'Fine. Yours?'

'Oh, fine, fine. It could be worse.'

'Mine's a bit grouchy. The doctor wants to stop her smoking. Well, to hell with that!'

'Tell me about how you are.'

'I'd be fine apart from this arthritis.' *He shows me his hip.* 'I can't walk without a stick. And my sight . . . I can't read any more. Not that I used to read that much. But I like to have a look at the news sometimes.'

'You should change your glasses.'

'These ones are all streaked. Here, have a look. I don't remember where they came from. I found them . . .'

'I promised that you'd inherit mine.'

'I could see better with one eye, but the other one was worse. But these are fine for the garden. And over time the good eye has gone the way of the bad one. And anyway, you get soil on the lenses . . .'

'Lying on the ground like that, they must get covered in earth.'

'Sometimes. But when my glasses are clean and I'm lying like this, I notice things you can't see when you're standing up. Details, you'd call them – worms, insects. And you see that the earth, which looks like a brown mulch from up there, is made up of tiny bits of stone. You can see mica, little pieces of rock. It's good being able to see the earth with your nose almost in it. You understand how it's made. You see seeds, stones, insects, bits of

leaves, all sorts of things. The things that feed the vege-
tables. But all the same, it's lucky we put the rest on it . . .
the personal fertilizer.'

'You see all that . . .'

'I can even taste the vegetables as I go. It's different
seeing the world lying flat on your stomach. People look
like monuments. They've got big legs and tiny heads.
Like the Eiffel Tower.'

'Do you stay like that all day?'

'No, sometimes I turn over and look at the sky . . .' *He
turns over onto his back.* 'I don't think I'm going up there.
I can't see me up there. More likely I'll be down here
with the roots and the moles. I'll be more at home. I'd be
lost up there – nothing would be familiar. When you look
at the sky from down here, lying like this, you can't tell
where it ends. They talk about "the sky, the sky", but it's
transparent. There's nothing there. It's like God. Some
gases, perhaps . . .'

'That doesn't seem to worry you.'

'No. You know, when you don't have that much power
left in your batteries and you feel yourself getting weaker,
you get used to the idea of being snuffed out. And then

the same current makes you move and makes you want to keep going.'

'You feel like you're going to break down . . .'

'No, it's not a breakdown, it's that you no longer want to do things. It's not that bad. You stop wanting to do things, and you're not sad not to do them because you don't want to any more. It's like eating when you're not hungry . . . It's the same for the other . . . The wife . . . poor thing, she holds my hand – she held it when I was in hospital, and that makes me want to cry. It's silly – there's no reason for it – but it gets to me though she's not saying anything, just holding my hand . . . She's none too lively, either. She's not in such good shape. I'm the one who should be holding her hand. We're turning into old folks.'

'So why tire yourself out with the garden?'

'This garden's my life. I don't know how to do any-thing else. It fills my time. Look around – I don't think I've ever grown such fine vegetables. It's as if they enjoy growing when the gardener's lying on the ground. Have you ever seen beans growing over the tops of the poles? And look at the lettuces – just look at them!'

'Those are lettuces?'

'Help me up. It pulls when I stand up. I can manage by myself but it's easier like this . . . You see, standing up I have trouble bending. My stick, please. Do you want some vegetables? Take what you want. Have a lettuce from over there. The wife – yours, that is – will be pleased . . . Take a real beauty.'

'What's a beauty?'

'Good, succulent, well shaped, attractive, young, beautiful – you know . . . You'll have me crying in a minute.'

I take a lettuce and support him to the end of the garden. I close the wooden gate, and accompany him home.

The next day he was dead. It was one of his neighbours on the estate who told me. Without any preamble she said: 'He's dead. He didn't suffer.' In the night they took him back home. He was on the big bed on a blanket with a reptile pattern. I spoke to him without opening my mouth. I could hear his replies, the silences mixed with the visitors' prepared phrases.

*

'Say what you like, he went quickly, poor man.'

'My condolences.'

'Thank you.'

'I can't come tomorrow. We've got the children arriving from Paris. I'd like to have seen him off.'

'It looks as if he's smiling.'

'That's him . . . That's him all right.'

'Whatever you do, when it's your turn, it's your turn . . . Rich or poor, we're all the same.'

'He was brave, you know. A brave man . . . brave and good. Always willing, always ready to do you a good turn.'

'If you need anything . . .'

'You shouldn't stay on your own.'

'You should go and stay with the children, visit each of them in turn . . . See the grandkids.'

'Not two months ago I saw him fishing. Who would have thought it?'

'Have a rest, dear. Do you want some soup?'

'No, thank you. Nothing. I can't swallow.'

'He hasn't changed at all. You can't tell how much he suffered, poor man.'

'That's him. That's him all right.'

A few days later I visited his grave in the cemetery.

<div align="center">*</div>

'Remember one day you asked me to paint the things you wanted to have by you? Well, I've painted some stuff I thought you couldn't do without . . . Here's a picture of the sky I did on a slate that fell off the studio roof. A blue sky . . . And another one, a stormy one this time, on another slate . . . A pebble . . . I painted one from the railway, one of the ones you gave me . . . A handful of coloured gravel on a lithograph you saw me making . . . Some kippers on paper offcuts . . . A bit of bread on plywood . . . A cup of tea with sugar. I painted the tea packet with an elephant on it and I've done the sugar in cubes . . . The grass in the field, and the path to the studio . . . The bonfire of leaves, with smoke. Lots of smoke. I even thought of covering everything with white smoke . . . Your wife's blue-grey eyes, with her cigarettes . . . A palm tree to remind you of your trip to Nice, cut out of corrugated card . . . A train ticket . . . A scooter. It's yours but I've simplified the stripes . . . The fish from the Vézère. Pectorals

from before your operation, copied from an old bust . . . A scythe, and an anvil to beat it on. Sometimes I think I can hear you beating it. I've also made a little bag with some wire for making one of your "claisps"; a knife for the bread and kippers, and to cut a stick; and some string . . . It was you who told me that it would always come in handy. Some secateurs . . . A view of the sea with boats . . . A photo of your children when they were little, with you and the wife . . . A bunch of wild flowers – you remember that time you criticized me for not painting flowers? The son-in-law's caravan . . . Some of those yellow stringless beans . . . and some dwarf-bean seeds . . . Leeks that haven't bolted . . . Mole poison . . . A bit of bacon to go with your dandelions . . . A tool kit for the scooter. A soup tureen full of soup . . . And a beautiful lettuce – like a fan that you could unfold, open up, and spread out – a really beautiful specimen. In remembrance of the beautiful lettuce that you gave me one day . . . Here you are. I'll leave it all with you. To do what you want with. They're for you. Here . . . Take them. Right, I'm going now.'